Postcard History Series

Calvert County

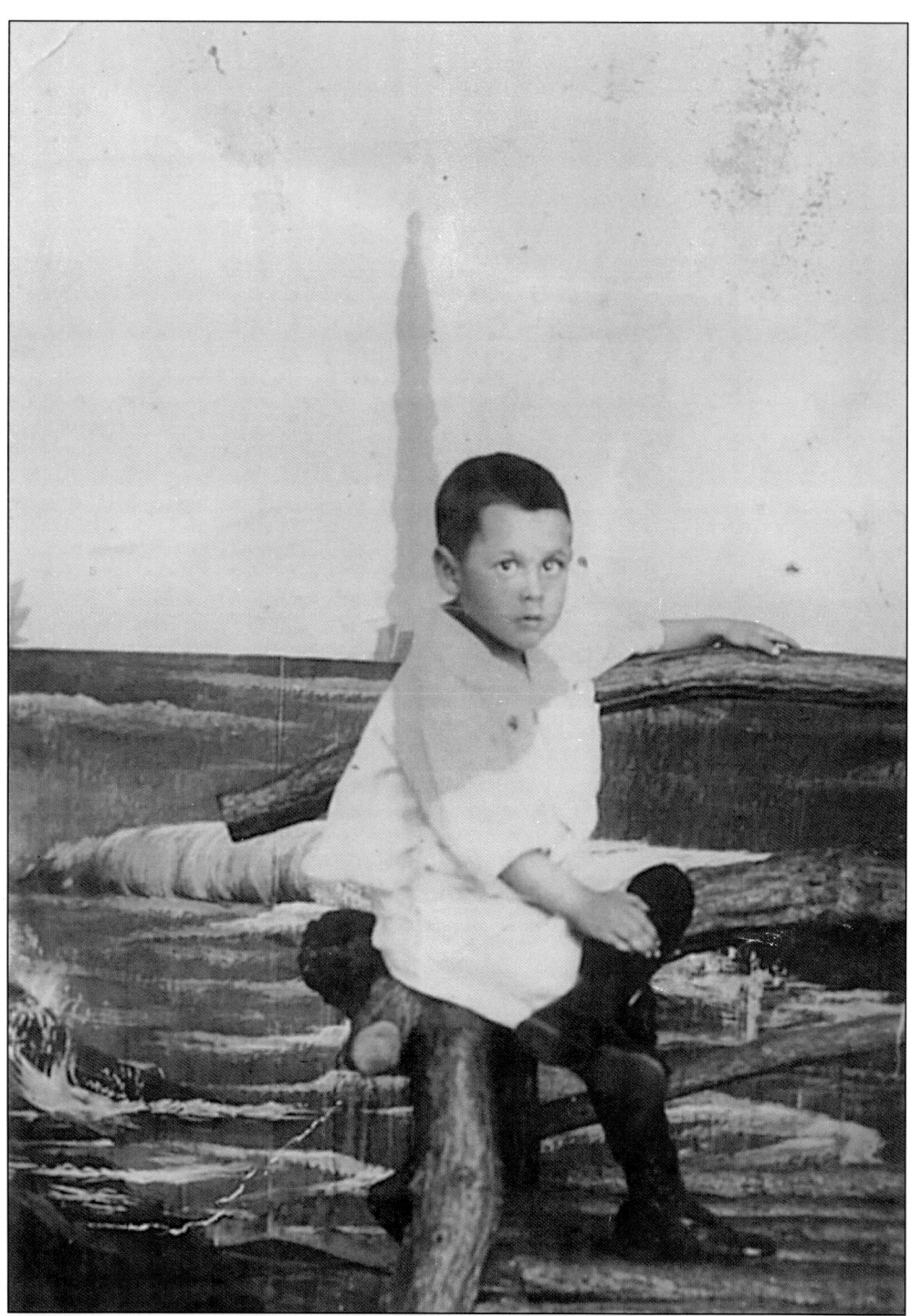

Pictured is the author's father, Charles A. Gray Sr., to whom this book is dedicated. Raised on a farm in Calvert County, he has seen the many changes that have taken place in this small rural county. This picture was taken in August 1917 at the Chesapeake Beach Resort, when he was four years old.

POSTCARD HISTORY SERIES

Calvert County

Carter T. Gray

ARCADIA
PUBLISHING

Copyright © 2000 by Carter T. Gray
ISBN 978-0-7385-0579-4

Published by Arcadia Publishing
Charleston, South Carolina

Printed in the United States of America

Library of Congress Catalog Card Number: 00-103468

For all general information contact Arcadia Publishing at:
Telephone 843-853-2070
Fax 843-853-0044
E-mail sales@arcadiapublishing.com
For customer service and orders:
Toll-Free 1-888-313-2665

Visit us on the Internet at www.arcadiapublishing.com

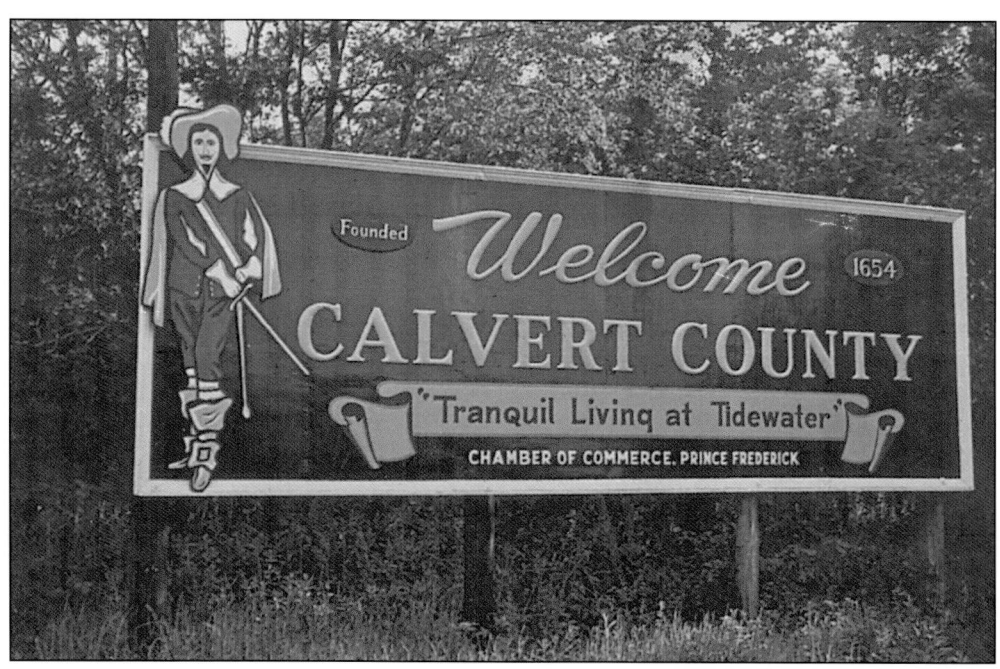

A very familiar sight as one entered Calvert County, this sign originally stood at the county line. James Leroy "Pepper" Langley, a famous sign and boat model maker in the county, painted it.

4

Contents

Acknowledgments 6

Introduction 7

1. North Beach 9

2. Chesapeake Beach 33

3. Prince Frederick 87

4. Solomons Island 97

5. Other Towns 123

ACKNOWLEDGMENTS

There are many people to whom I owe my heartfelt thanks and without whose help this book would not have been possible. Special thanks must go out to the following people for allowing me into their homes and listening to my endless questions: Margaret and James Leroy "Pepper" Langley and Althea McKinney for their expertise on Solomons; Bernie Loveless, who remembers the Chesapeake Beach Resort like it was yesterday and who went out of his way repeatedly to supply me with information (The entire Chesapeake Beach chapter was made possible because of him); and Thelma Robinson who helped a great deal with North Beach.

I must also thank the following for supplying help, information, and invaluable assistance: Jimmy Langley, Robert Hurry, Virginia Dixon, Jenny Plummer, Carolyn Sunderland, Glenn Webb, Charlie Mister, Fred Donovan, Mark and Rhoda Switzer, Mike Rockhill, the staff at the Calvert County Historical Society, Phyllis Lester, Wayne Hardesty, Jim Gscheidle, Barbara Gott, and Allan Hirsh Jr. from Ottenheimer Publishing, which is still in business after all these years.

And of course, last but not least, my father Charles, wife Carla, and son Willie for their patience and understanding while I was trying to get this project accomplished.

To the best of my knowledge all of the information contained within this book is true and accurate. All of the postcards and pictures presented in this book are from my personal Calvert County memorabilia collection.

The following references were used in the researching of this book: Richard J. Dodds' *Solomons Island and Vicinity: An Illustrated History and Walking Tour* (Calvert Marine Museum, 1995); Richard V. Elliott's *Last of the Steamboats: The Saga of the Wilson Line* (Tidewater Publishers, 1970); Charles F. Stein's *A History of Calvert County Maryland* (published by the author in cooperation with the Calvert County Historical Society Inc., 1976); and Ames W. Williams' *Otto Mears Goes East: The Chesapeake Beach Railway* (the Calvert County Historical Society Inc., 1981).

Introduction

Calvert County is a 35-mile-long peninsula surrounded by large bodies of water on three sides. The Patuxent River is on the west and south, and the Chesapeake Bay is on the east. Anne Arundel County borders Calvert to the north. A unique place in its own right, Calvert County is the smallest of the counties in Southern Maryland. It is also the fourth oldest county in Maryland, having been established in 1654, and currently it is the fastest-growing county in the state of Maryland.

The first county seat and the county's first town was located on the shores of Battle Creek and was appropriately called Battletown until 1683, when the name was changed to Calvertown. It included a courthouse, jail, and other buildings. As more colonists arrived and other towns were established, there was a need for a more centralized location of the county seat. In 1722, an act was passed to move the county seat to a location called "Williams' Old Fields," later to be named Prince Frederick, the present location of the county seat.

The next few years were quiet until the Revolutionary War. Many men in the county joined the Continental Army to serve their country, and the militia of Calvert County was formed to help protect the county. Still, with all the protection there was, the British raided the county in 1780 and destroyed many of the large plantation houses that had been built.

The following decades remained rather uneventful until the next invasion of the British, which occurred in 1814 during the War of 1812. The county saw a great deal of activity during this time, including the burning of more plantation houses as well as the courthouse. It was here that the well-known battle in St. Leonards Creek between the British fleet and Commodore Joshua Barneys' American flotilla was fought. The British continued up the Patuxent River, landed in the town of Benedict in Charles County, and proceeded to the City of Washington, where they burned the White House. A major rebuilding effort in Calvert County occurred over the next several decades. Many houses had been destroyed, and a new courthouse needed to be built.

In 1861, the War Between the States had begun. During this period, Calvert County became a very confused place. Many men in the county joined the Confederacy and fought for the Southern cause while, at the same time, the county was occupied by Union forces who established a camp for Confederate prisoners at Battle Creek.

The year 1882 saw a major disaster in Calvert County. Nearly the entire town of Prince Frederick was destroyed by fire, including the courthouse again. Very few buildings were spared. To this day, Calvert County has never recovered, as all the records dating back to the establishment of the county were totally destroyed.

The first great economic change to the county would occur during the years of the Second World War. Two naval training bases were opened at the southern end of the county, and this was a dramatic change for the natives of Calvert since it meant the biggest influx of strangers to the county to ever occur thus far. But the greatest economic boom in the area had to be the opening of the Calvert County Nuclear Power Plant in mid-1970. Many jobs were created, and the image of Calvert County began to change.

Calvert County has been, for many years, one of Maryland's hidden treasures. As we enter the 21st century and Calvert County's population nears 75,000, I guess one could say that the treasure has been found and that it is a sad situation for "ole timers" who claim "It sure ain't like it use to be!" But things must change with the times, and Calvert County will undoubtedly remain the special place that it has been since 1654.

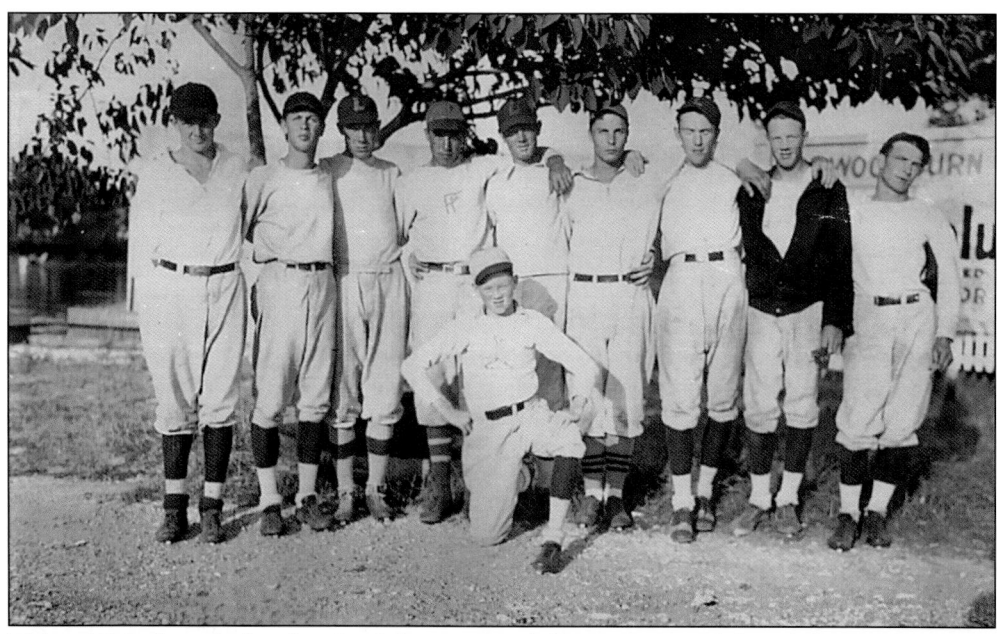

This c. 1932 photo is showing the Solomons baseball team. Pictured from left to right are the following: (first row) James Leroy "Pepper" Langley; (second row) Edward Daniels, Clifford Pardoe, unidentified, unidentified, Wyatt Pardoe, Joseph E. Johnson Jr., unidentified, Earl Pardoe, and Calvin "Bunks" Dodson.

One
NORTH BEACH

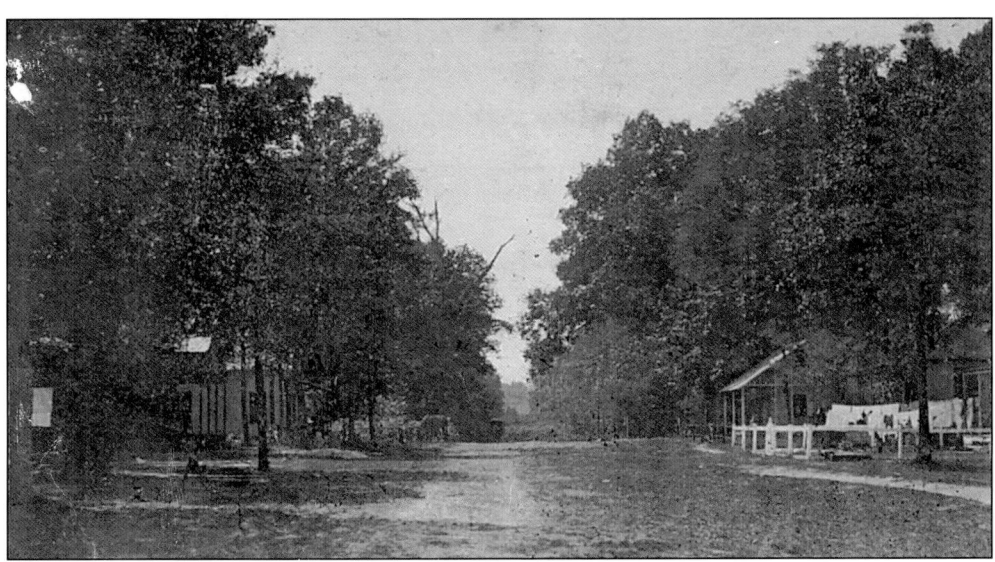

North Beach is the northernmost town in Calvert County. In the early years, the town was known as North Chesapeake Beach. This very early card was mailed August 6, 1909.

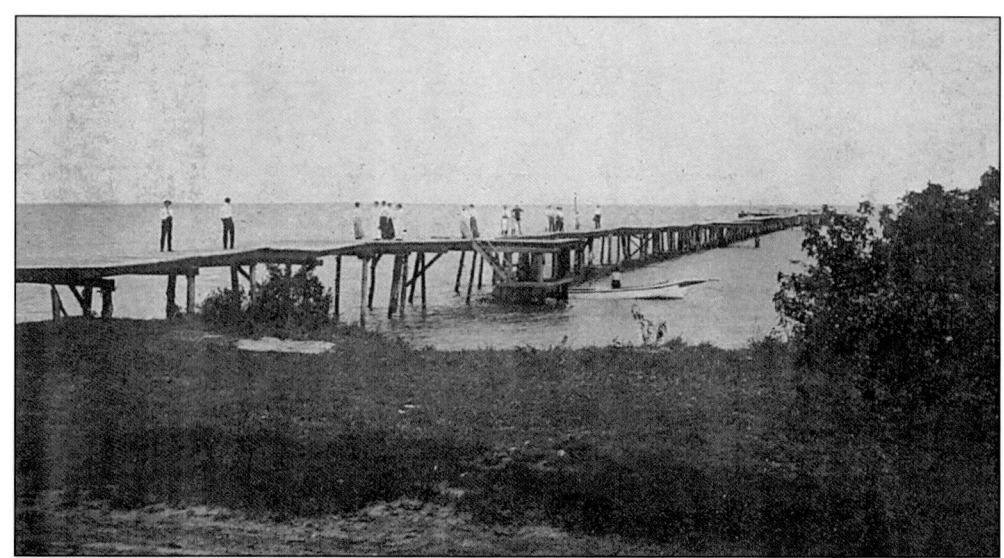

The town of North Beach was originally platted in the year 1900, the same year the Chesapeake Beach Resort to the south was opened. A Sanborn Fire Insurance Company map of 1923 shows a local population of 400 during the summer months.

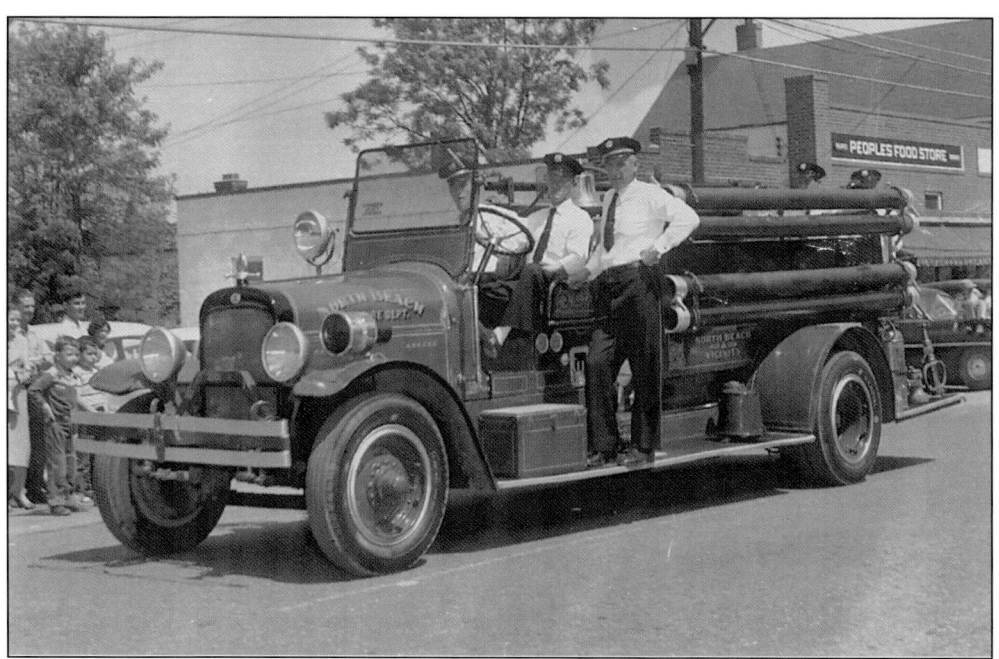

The North Beach Volunteer Fire Department was the first officially organized fire department in Calvert County. Organized on February 5, 1926, the department was served by Willard Ward as its first fire chief. Shown here is one of the company's first pieces of apparatus, a Seagrave pumper.

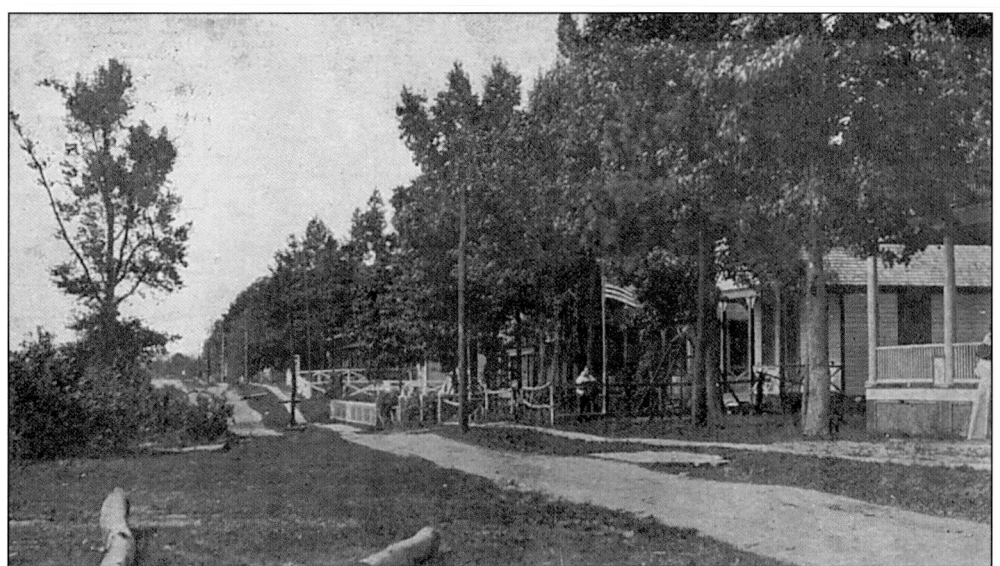

This early view of Bay Avenue, looking south, was sent on August 16, 1910. North Beach became legally incorporated in the year 1910, though many years later the town was still being called North Chesapeake Beach.

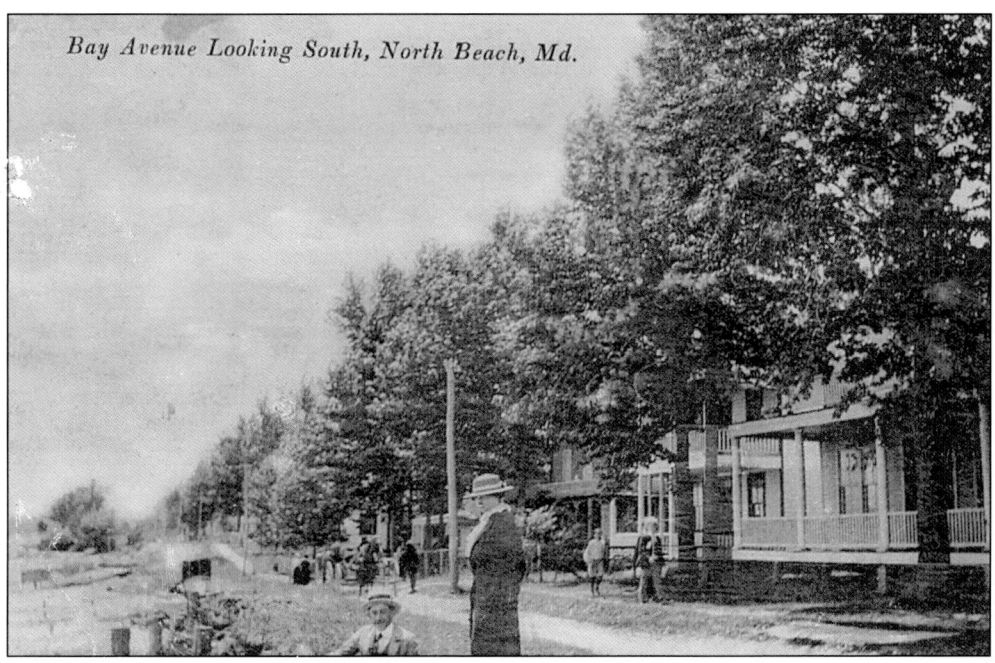

This is another early scene of Bay Avenue, looking south, that was taken at nearly the same location as the card above. The Chesapeake Bay is directly in front of Bay Avenue.

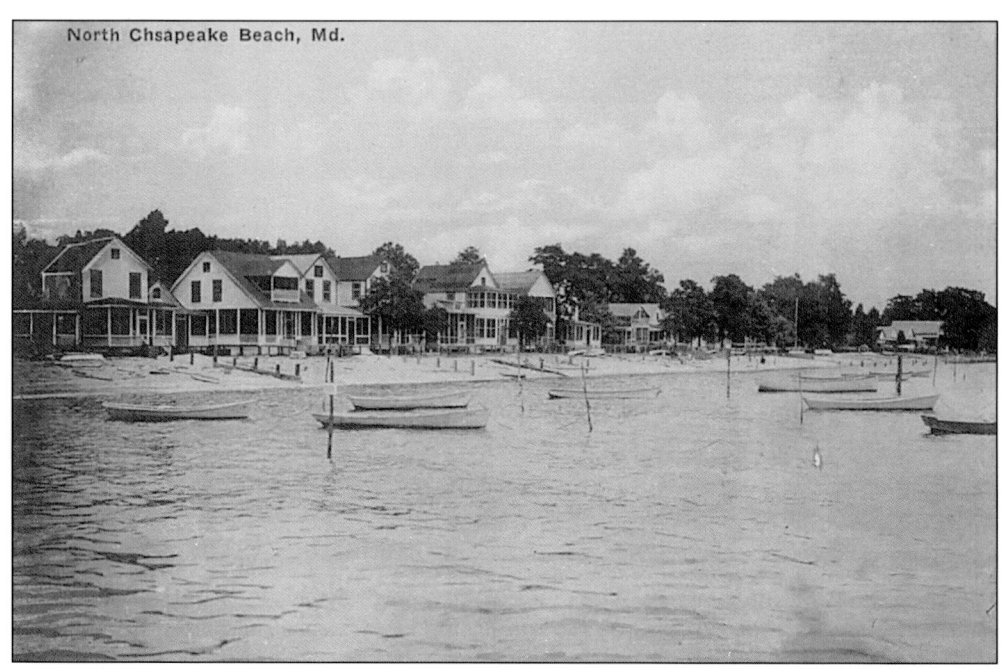

Made during the period when the town was still being called North Chesapeake Beach, this early scene shows how cottages were built directly on the shore itself. There is no beach whatsoever at this location today.

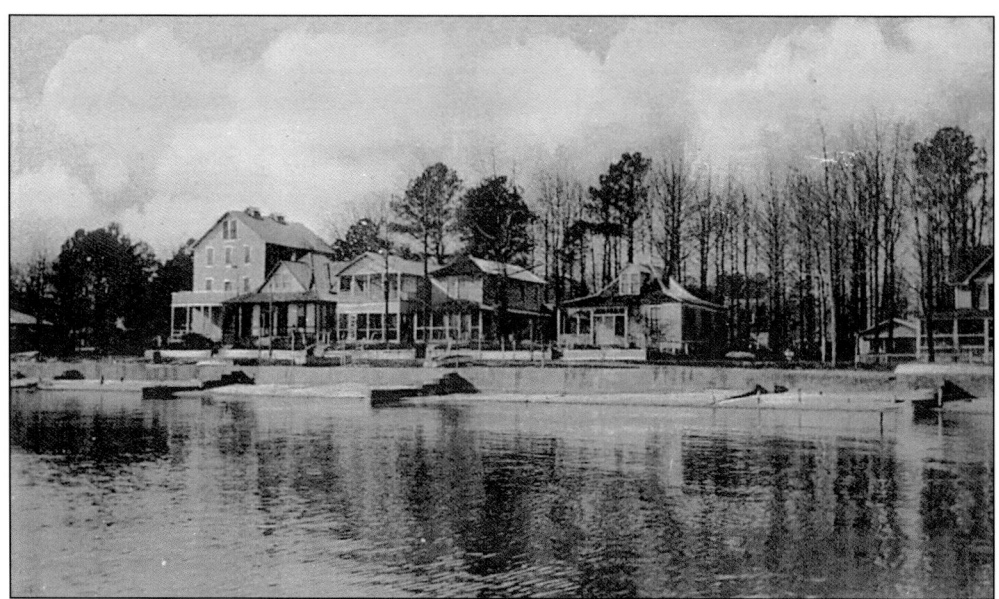

Visible in this Bay Avenue scene is the Cleveland Hotel, the building at the far left. The hotel was located at the corner of Second Street and Bay Avenue, and the smaller building in the middle of the view was a private residence known as the Rosemont.

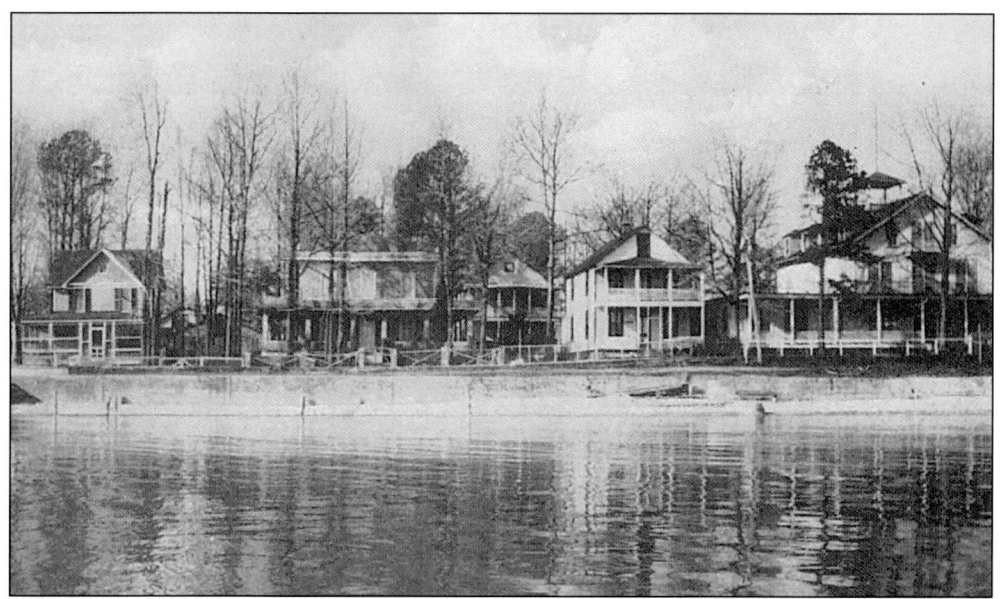

This scene of Bay Avenue shows the Calvert Hotel, which sat at the corner of Third Street and Bay Avenue. Very few of the original houses that were once located along this bay-front stretch are still in existence. This postcard was mailed on September 8, 1922.

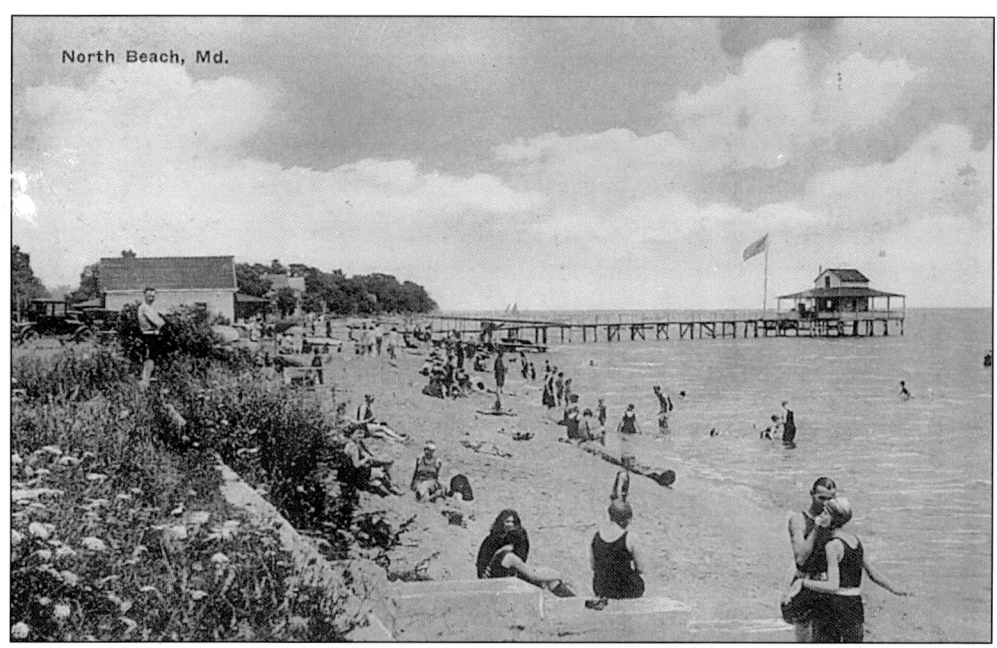

It is evident in this scene that there was a healthy expanse of beach in front of Bay Avenue prior to the hurricane of 1933. Notice also that the large dance pavilion has not yet been built. This card was mailed on September 4, 1923.

13

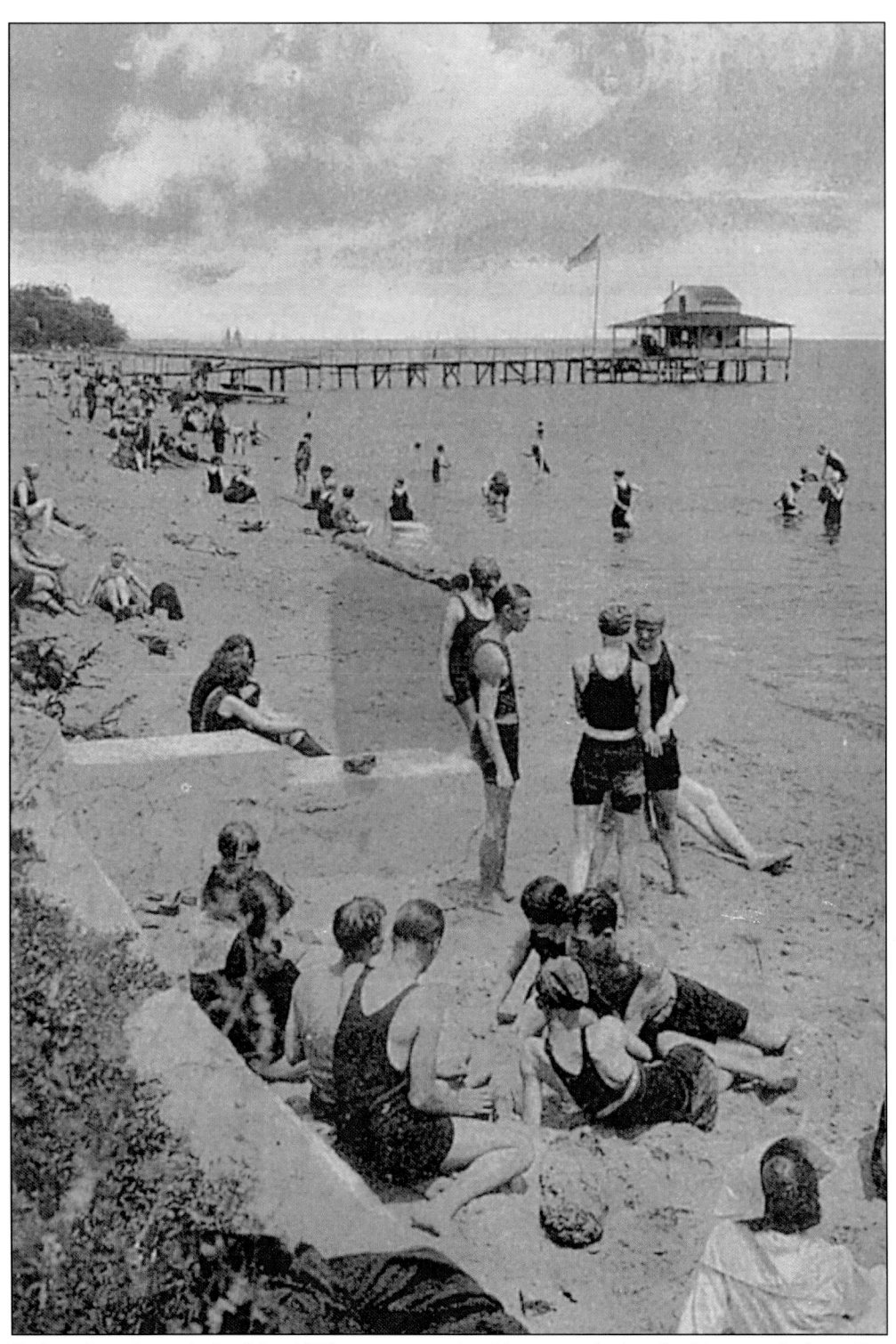
Bathers in suits typical of the 1920s era appear in this postcard view, looking north from Bay Avenue. The card was sent on August 27, 1925.

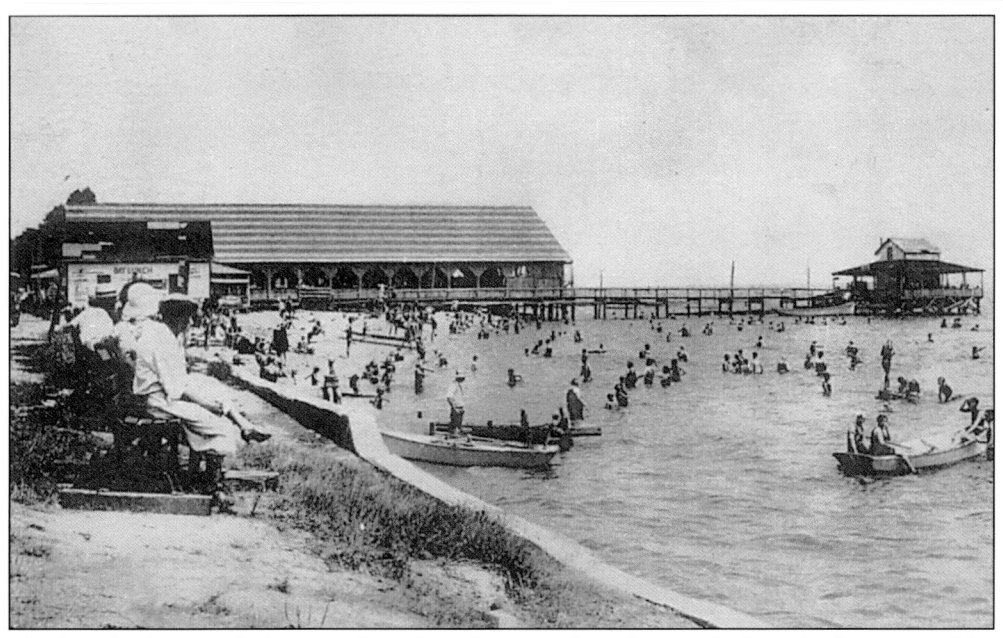

The long building with the striped roof is a dance pavilion that was built in the later part of the 1920s. The Bay Lunch building can be seen on the left. (Published by H.M. Dowling.)

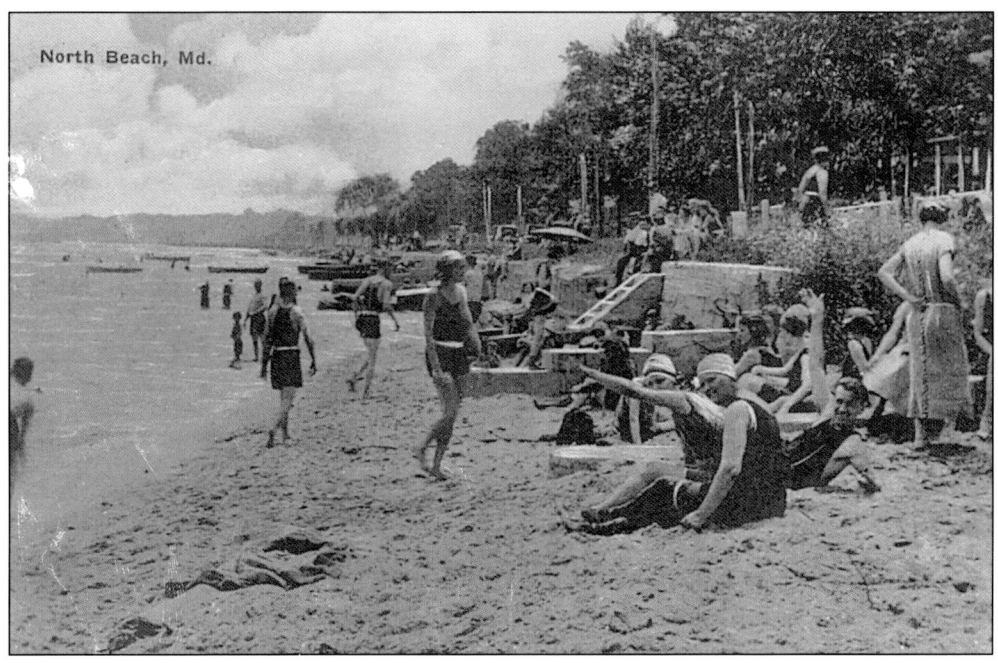

This c. 1925 scene shows bathers in front of Bay Avenue as well as the trees that once lined the shore in this area before the 1933 storm.

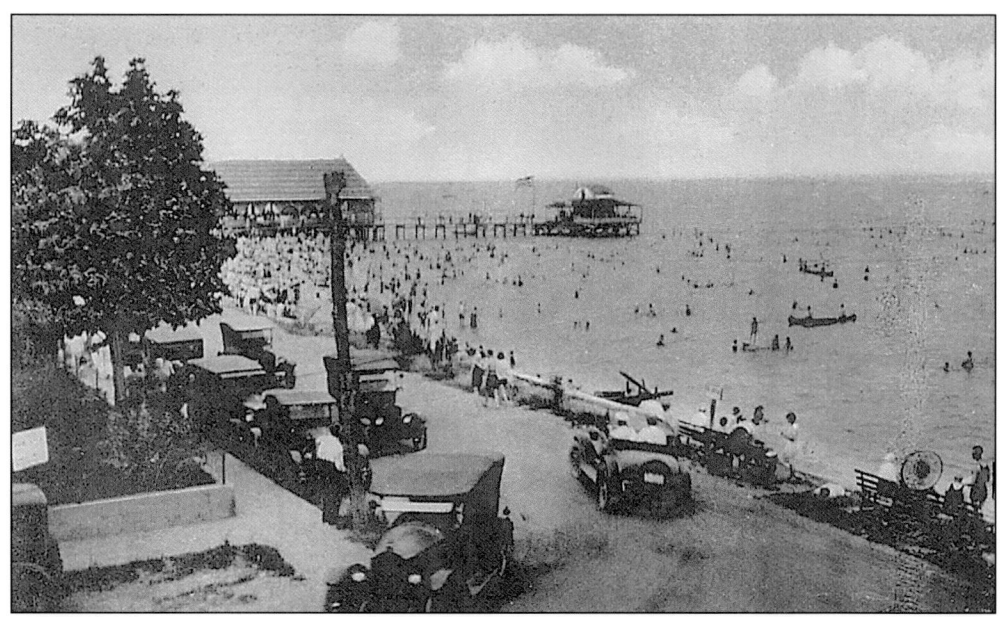

Looking north toward Oscar Marshall's Crab House, this view was evidently captured from the upper level of the Calvert Hotel. One must wonder how many accidents occurred on this bend.

In this excellent close-up view of Oscar Marshall's Crab House, a large crab cooker located on the porch—where the crabs would be cooked and served—and the open area of the dance pavilion are visible. (Published by H.M. Dowling.)

16

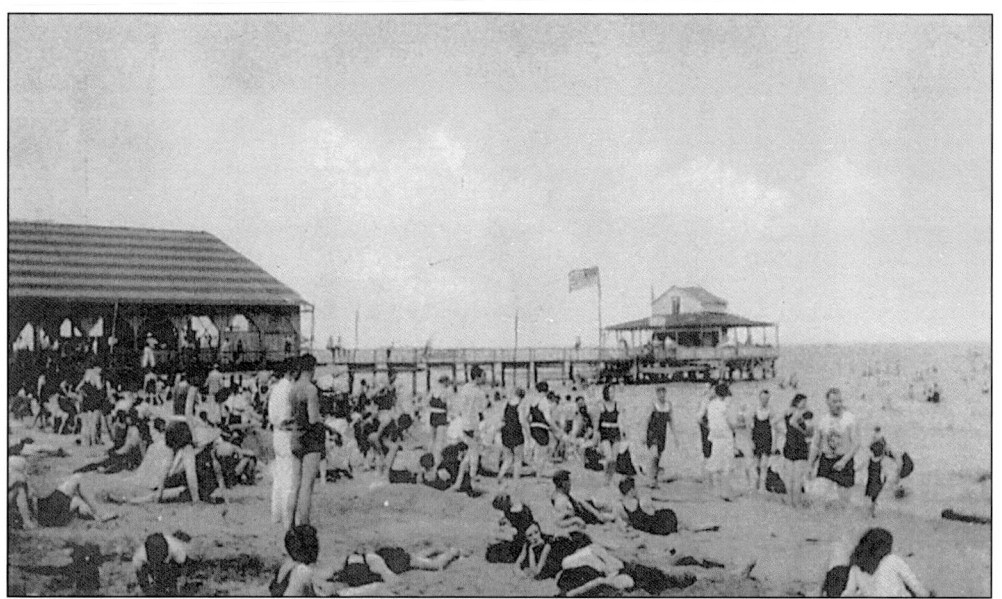
During the hurricane of 1933, Oscar Marshall's Crab House was completely destroyed, and the end of the dance pavilion, the building with the striped roof, was badly damaged.

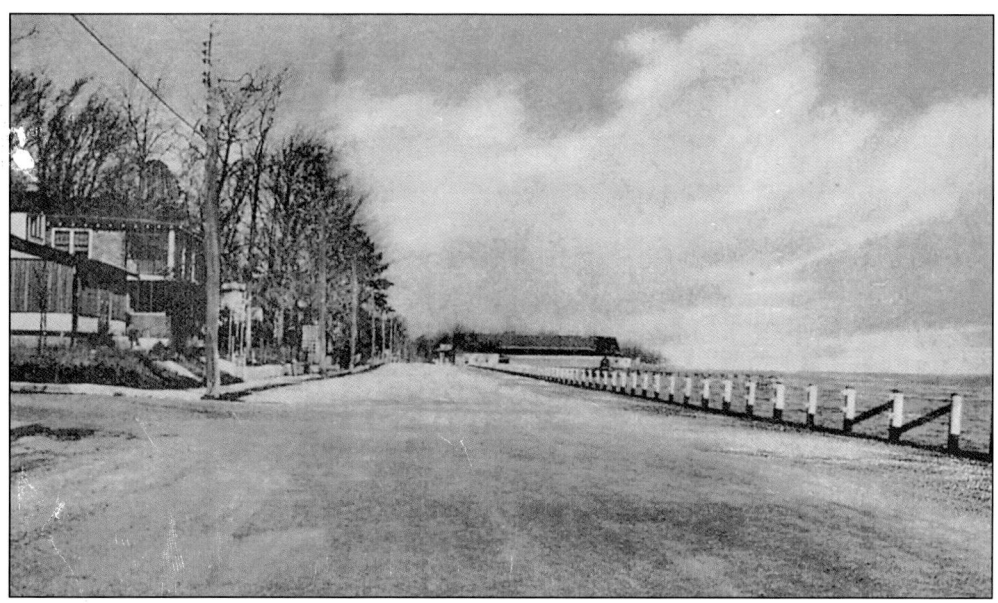
Looking north from Second Street and Bay Avenue, this view includes a widened road with a newly added guardrail. It is a picture that must have been taken after 1933 since Oscar Marshall's Crab House is now missing.

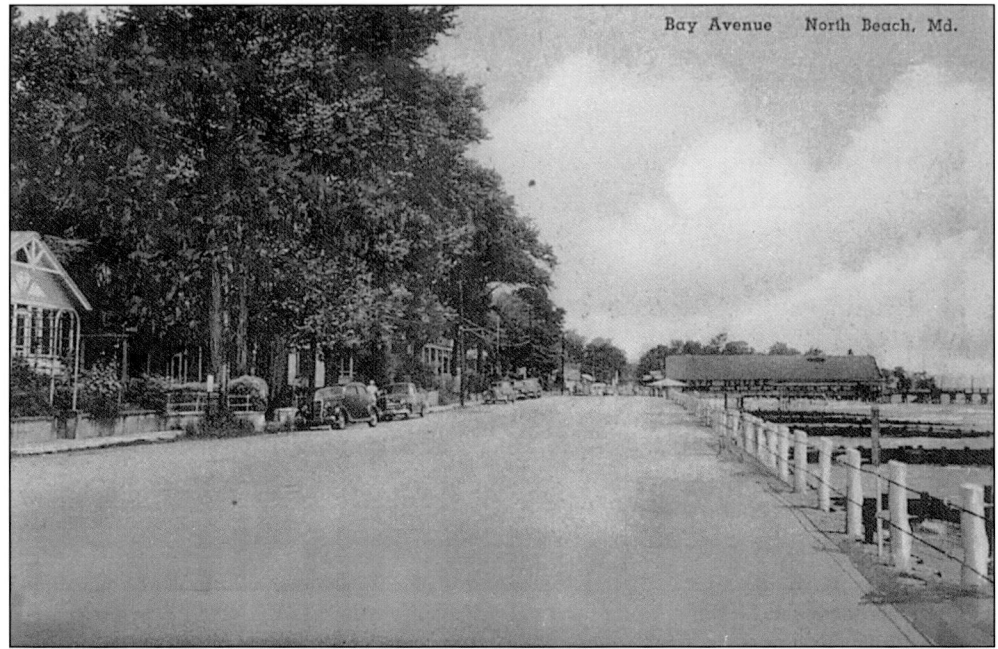

The building on the far left in this scene of Bay Avenue between Second and Third Streets is the Rosemont. It was named this for the roses that always graced its front lawn. (Published by R.D. Grund, North Beach, Maryland.)

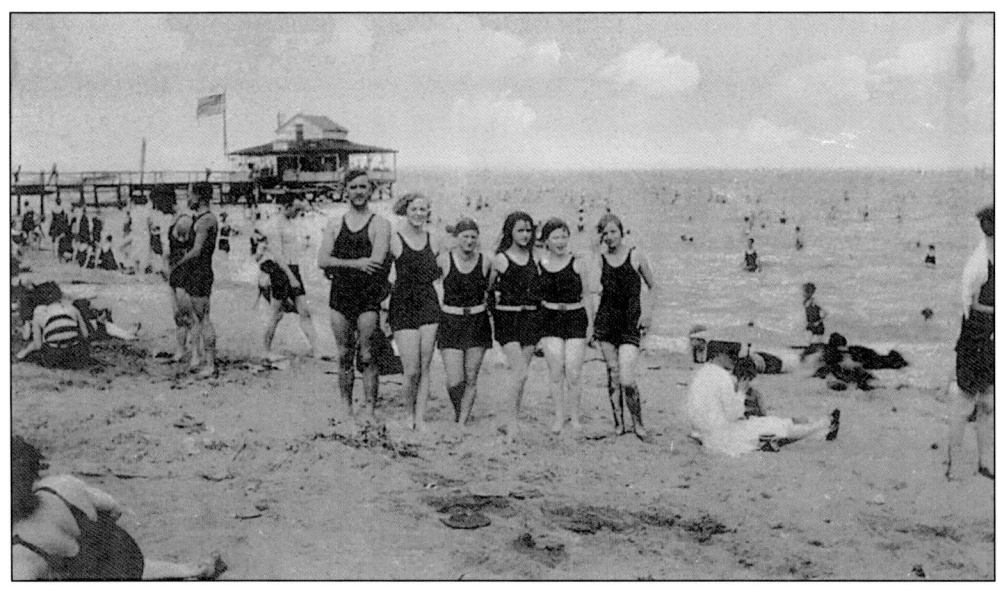

Looking out toward the bay at the crab house, this group looks more than happy to pose for the camera. In addition to the destruction of the crab house, the 1933 hurricane also caused the severe erosion of the beach.

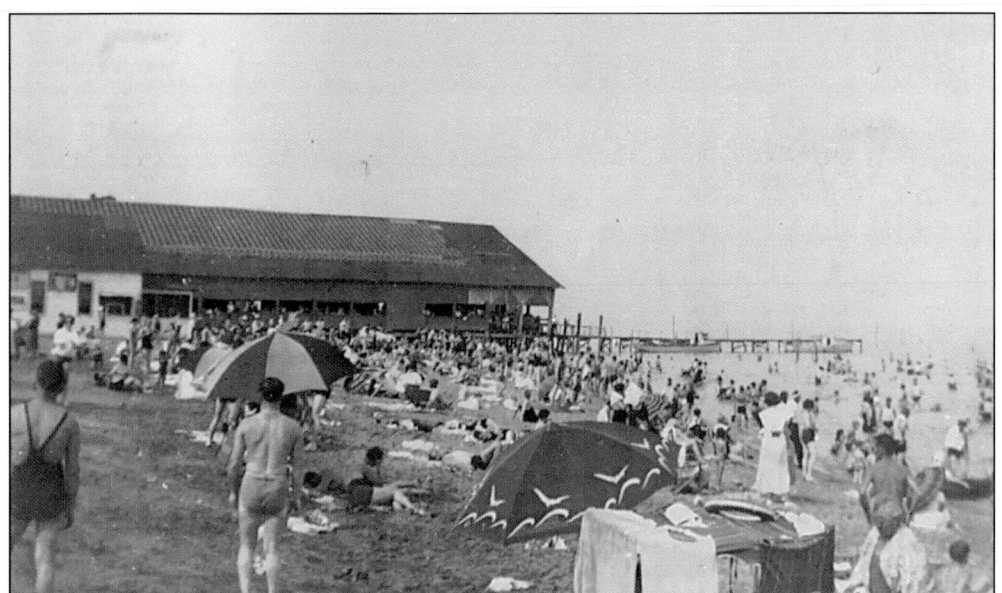

The beach was a very popular attraction as this crowded photograph taken sometime after 1933 shows. Notice that the crab house is gone and that the roof to the dance pavilion has been repaired following the 1933 storm. This postcard was mailed on August 19, 1937.

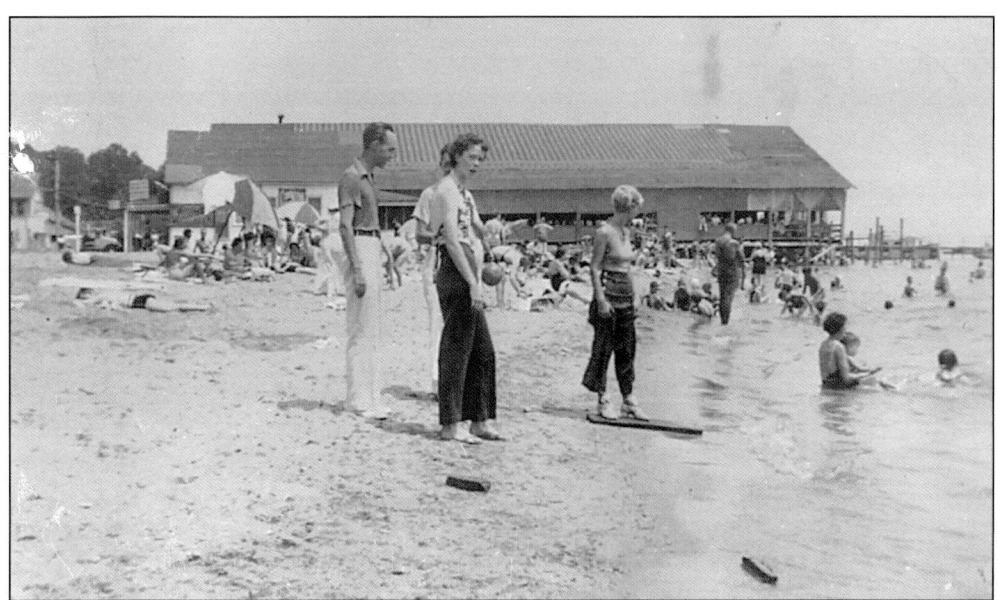

The large dance pavilion, located opposite the current Fifth Street, held a variety of activities. One could see movies inside, play basketball, or go roller-skating. The pavilion was torn down around 1955.

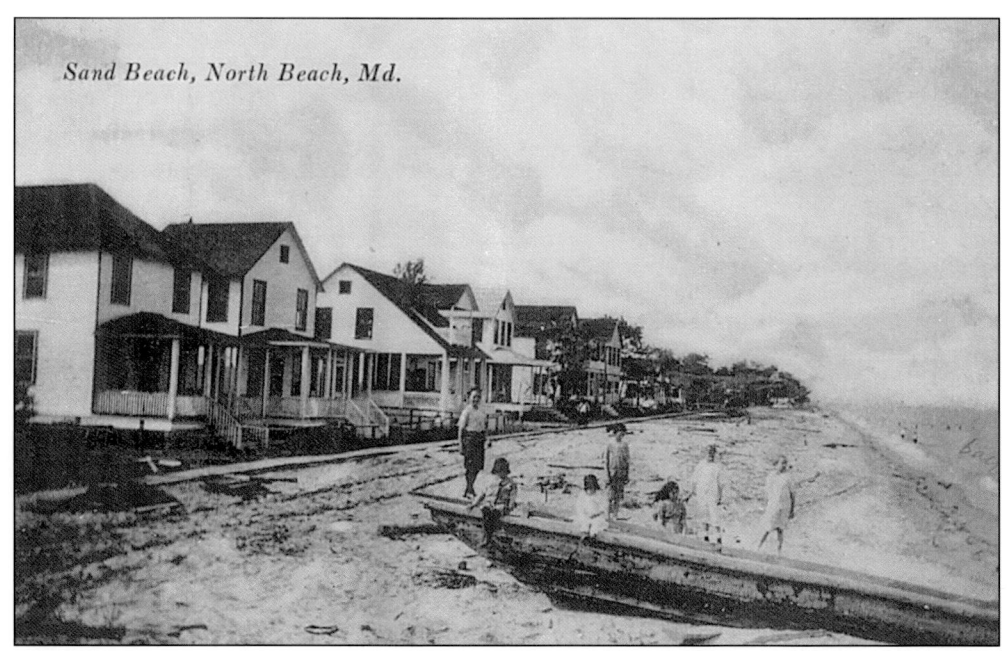
Located at the northern end of North Beach, from about Fifth Street northward, was an area called Sand Beach. This is a very early view of the area that was mailed on September 5, 1916.

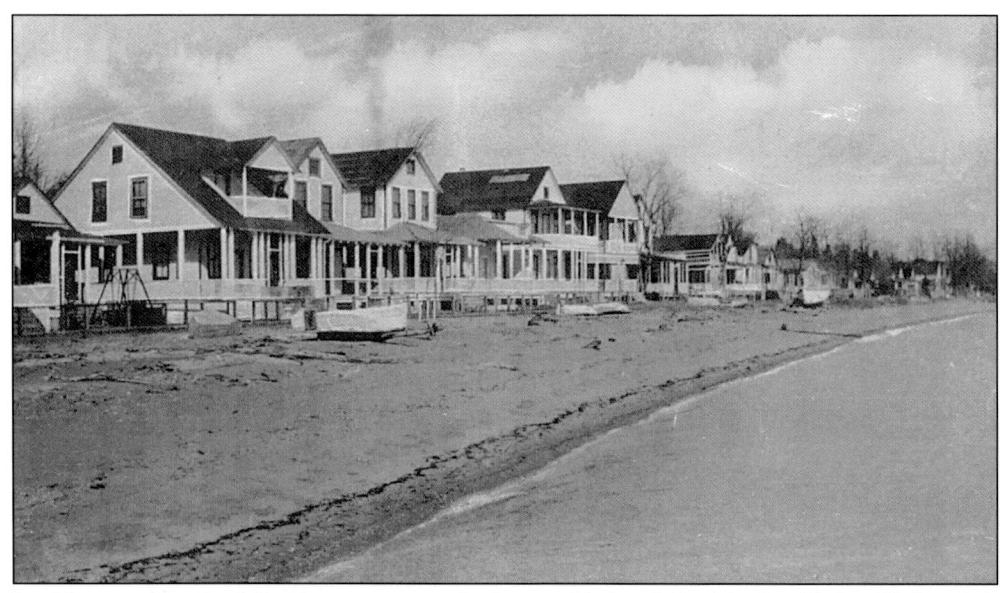
Looking north at Sand Beach, one can see the long, wide beach in this view. Today, this beach is the location of Atlantic Avenue. (Published by R.D. Grund, North Beach, Maryland.)

Showing the northernmost end of Sand Beach, this view, captured during the winter months, shows how cottages were boarded up while waiting for the summer season.

Seventh Street is located where the parked cars are on the left side of this scene. North Beach has always been threatened by erosion, and currently there is no beach at this location.

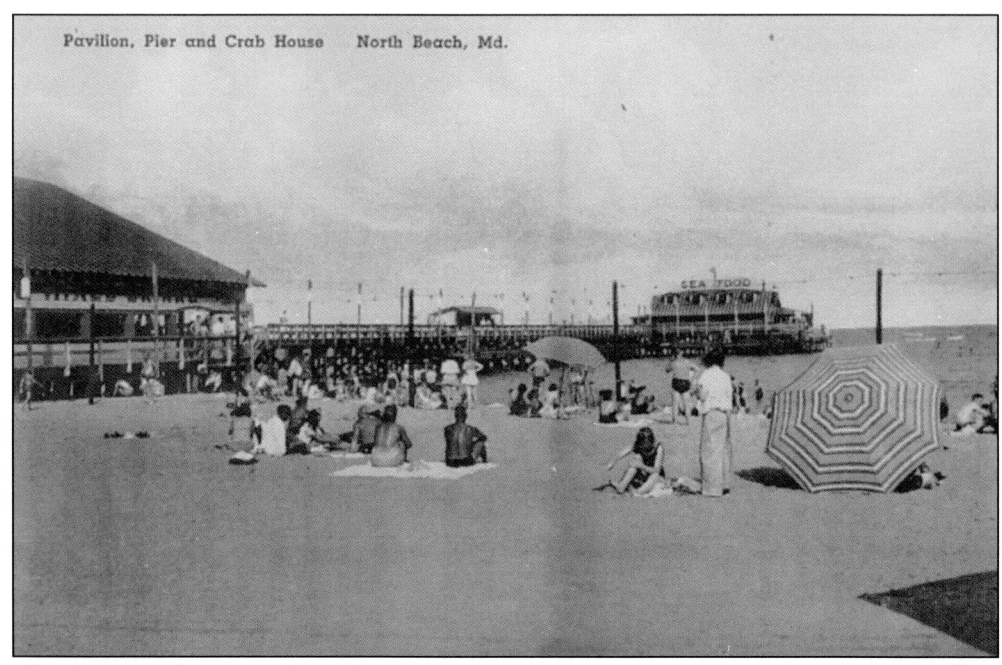

The dance pavilion is to the left, along with the pier and seafood restaurant that were built after Oscar Marshall's Crab House was destroyed in 1933. (Published by R.D. Grund, North Beach, Maryland.)

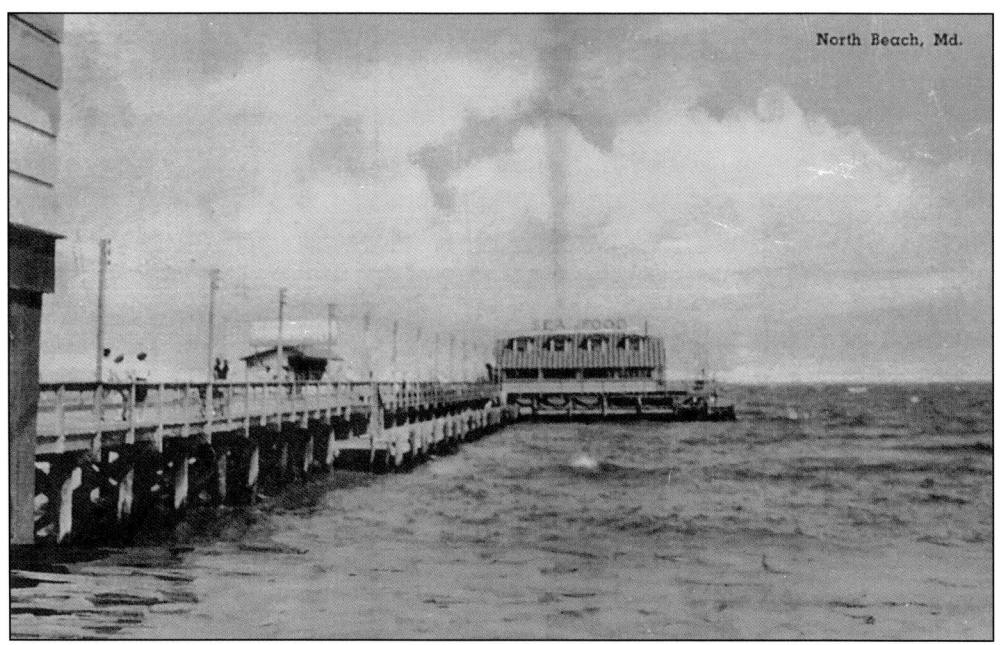

The building in the center of the pier seen here housed a rowboat rental business operated by Heber MacWilliams Jr. The restaurant, called the Reef, was destroyed by fire on April 17, 1976.

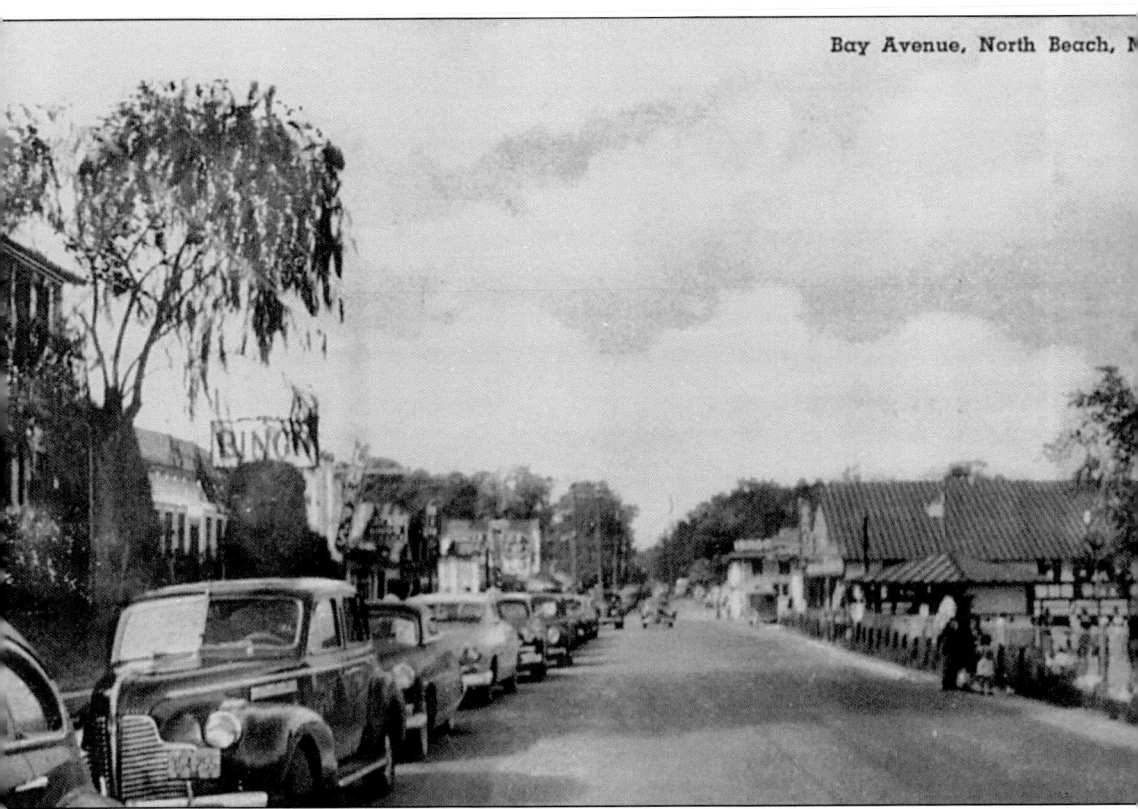

The large complex of buildings on the left, owned by Joseph and Abraham Rose, consisted of bingo halls, arcades, a casino, a musical bar, and a snack bar. Unfortunately, the businesses burned to the ground, causing an estimated $200,000 in damage, on October 10, 1951.

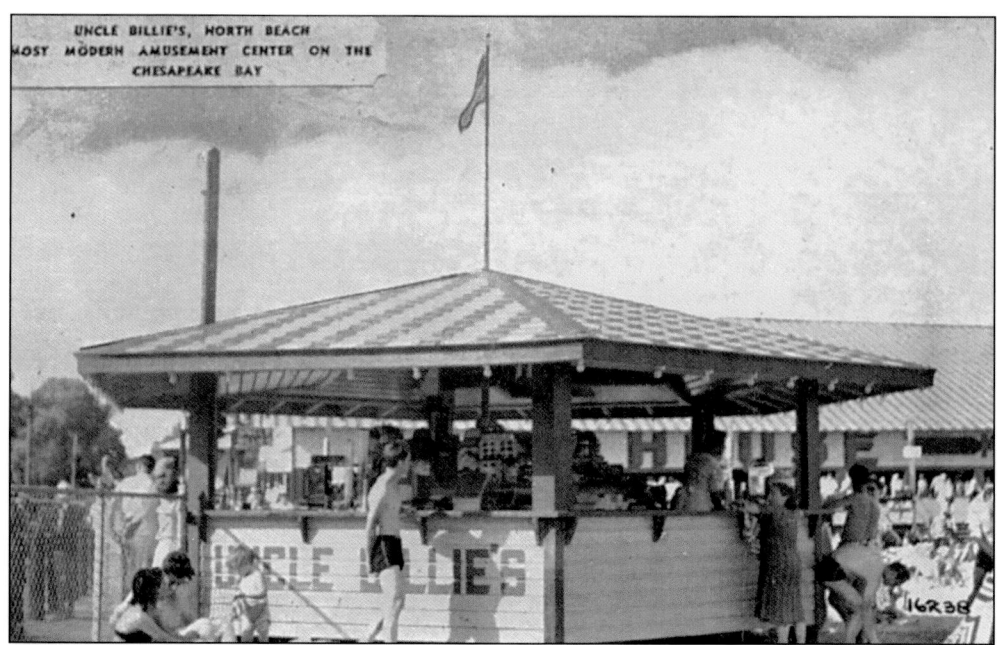

The octagonal shape of Uncle Billie's snack stand is apparent in this postcard view. Owned by Charlie Nelson, Uncle Billie's was named after Billy Hughes, a gentleman who worked there.

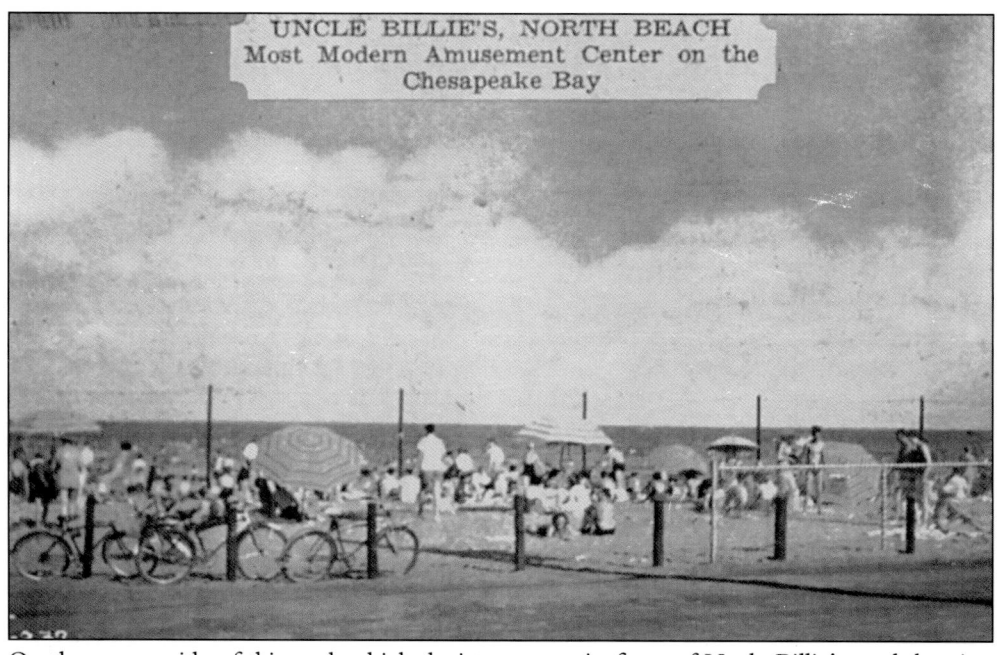

On the reverse side of this card, which depicts a scene in front of Uncle Billie's snack bar, is a caption that describes the business as having everything: dancing, movies, Money Night, a bath house, and many other recreations.

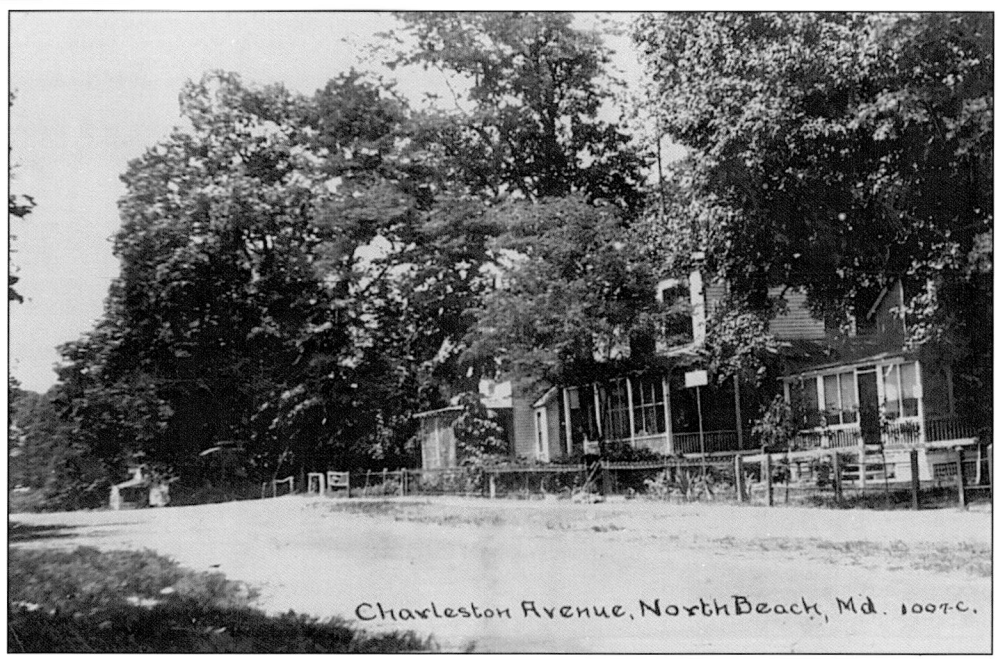

This early picture of Charleston Avenue is postmarked July 6, 1917. Once located at the northern end of town, Charleston Avenue no longer exists.

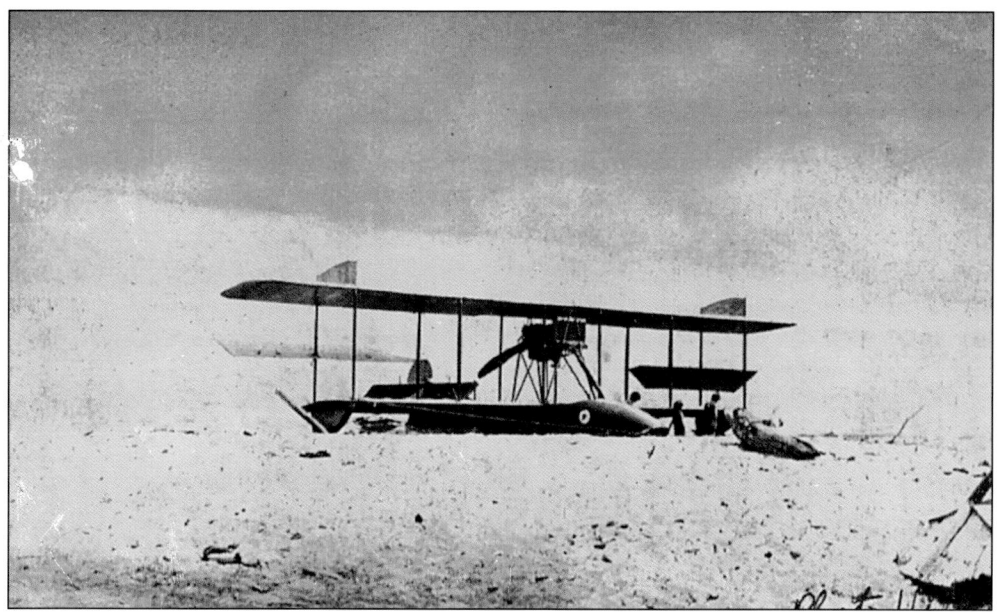

This is a rare c. 1920 view of a hydroplane on the beach. Seaplanes were brought in to North Beach to take brave souls on a trip over the town. (Published by Auburn Post Card Manufacturing Company, Auburn, Indiana.)

The Alta Cottage was later called the Alta Hotel. After that, it was called the Cotton Club and, then, Blackie & Lil's. Though greatly altered over the years, this building stood until the late 1990s and is currently the site of an apartment complex.

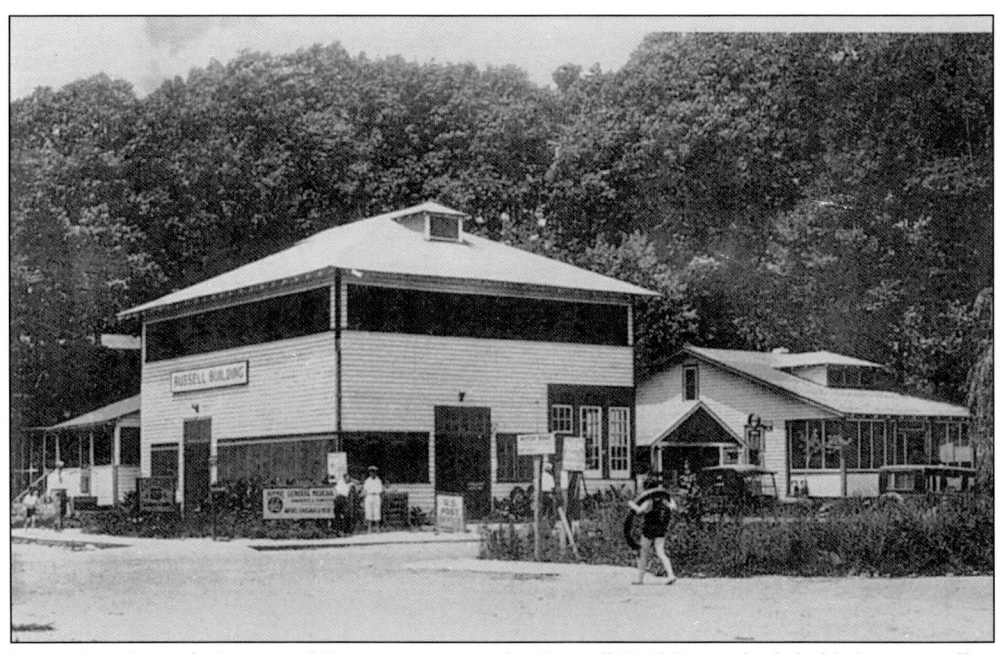

Located at Seventh Street and Bay Avenue was the Russell Building, which held the post office and sold general merchandise along with groceries. Thursday's Bar and Grill is currently on the site where this building once stood. (Published by H.M. Dowling.)

This boarding house, operated by Mrs. Kerns, was located between Second and Third Streets on Bay Avenue. This early postcard has a postmark of August 11, 1914.

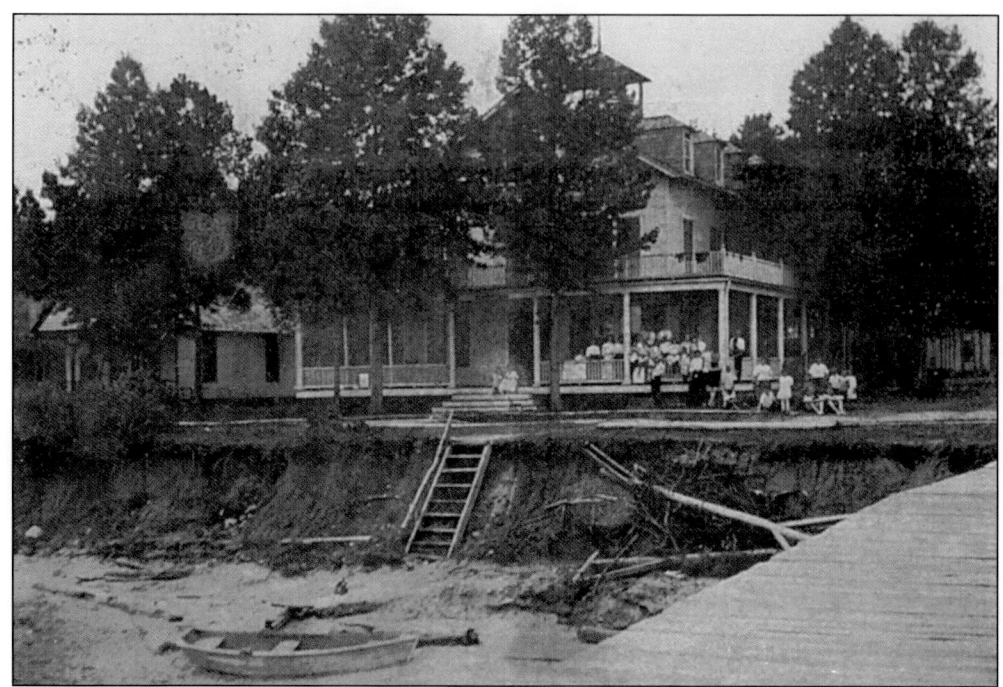

This early view of the Calvert Hotel, postmarked September 2, 1912, shows Bay Avenue before a concrete wall was erected to help stop erosion. The writer penned on the back of the postcard the following message: "have front room behind tree, 1.50 a day. Had a country dance here last night."

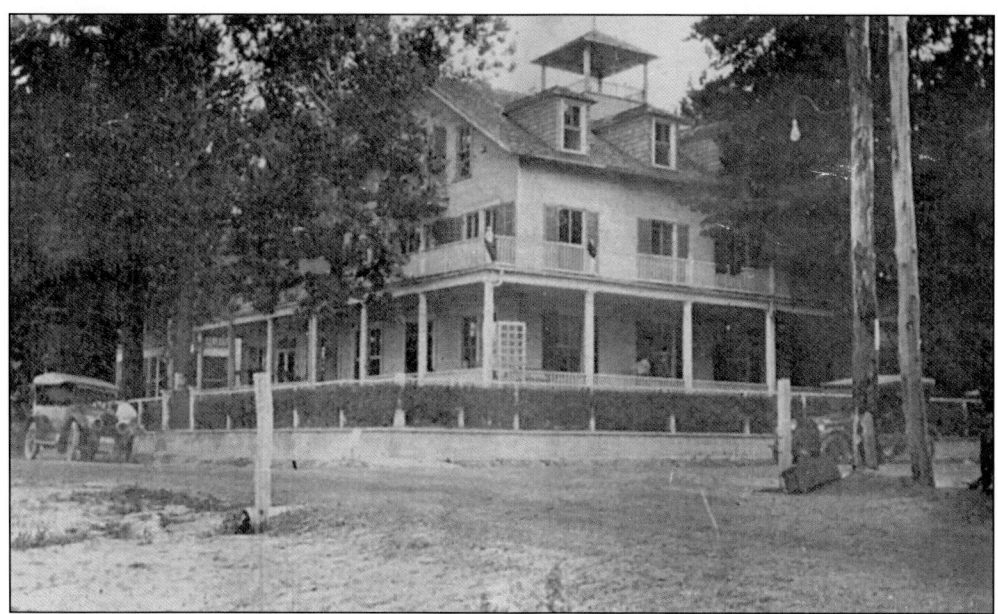

The Calvert Hotel, located at the corner of Third Street and Bay Avenue, is seen here *c.* 1920. In 1968, Earl and Marie Kosche became the owners. Following the demolition of the hotel during the latter part of the 1970s, the site became and has remained a vacant lot.

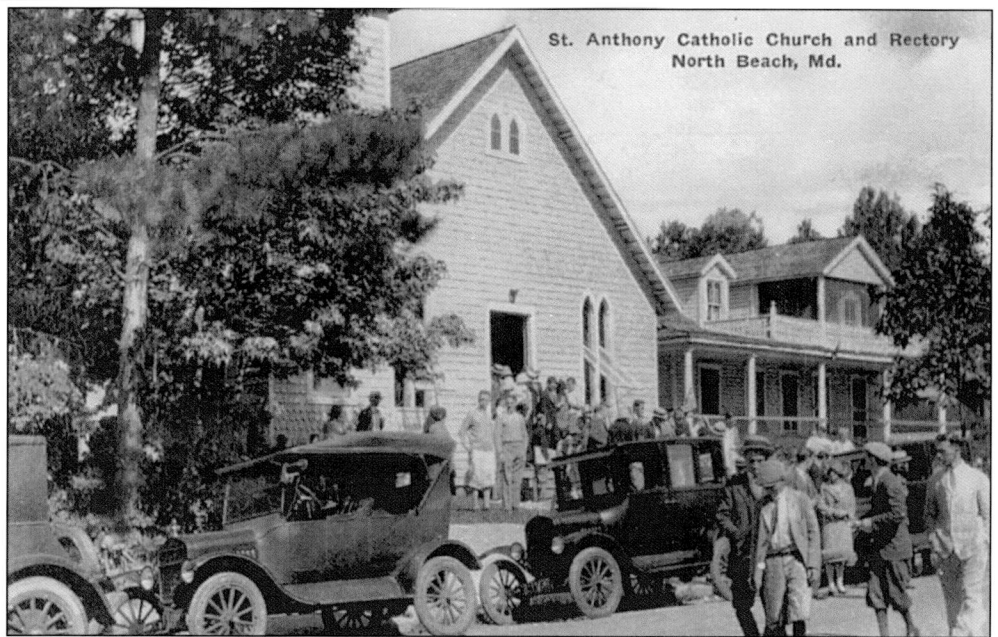

This c. 1920 view shows the St. Anthony Catholic Church and rectory. Before this church was erected, services were conducted at the Townsend residence located near the bay front.

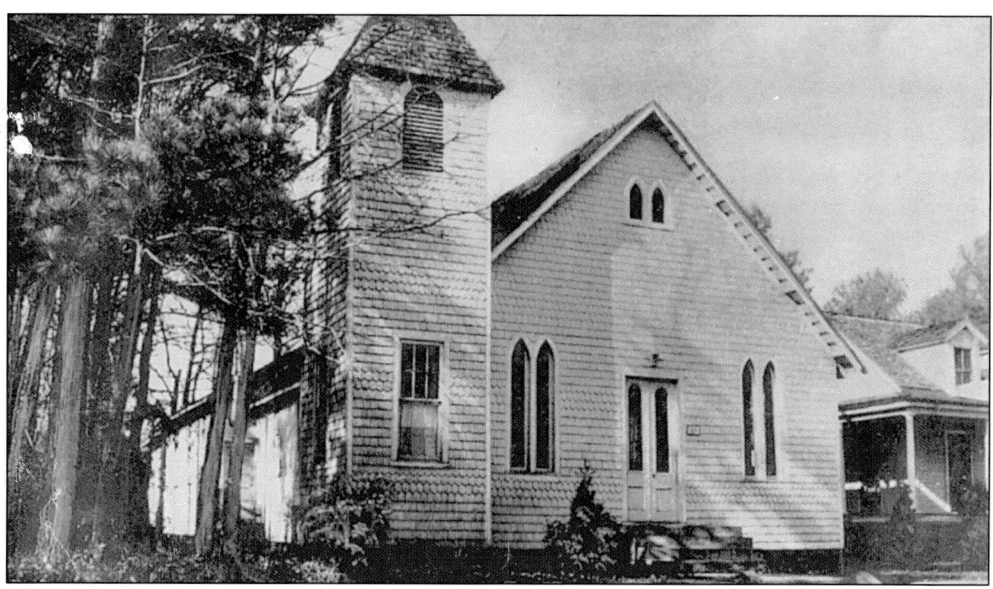

St. Anthony Catholic Church was the second Catholic Church established in Calvert County. This wooden structure was torn down, and the existing brick church was erected in 1958 on the same site.

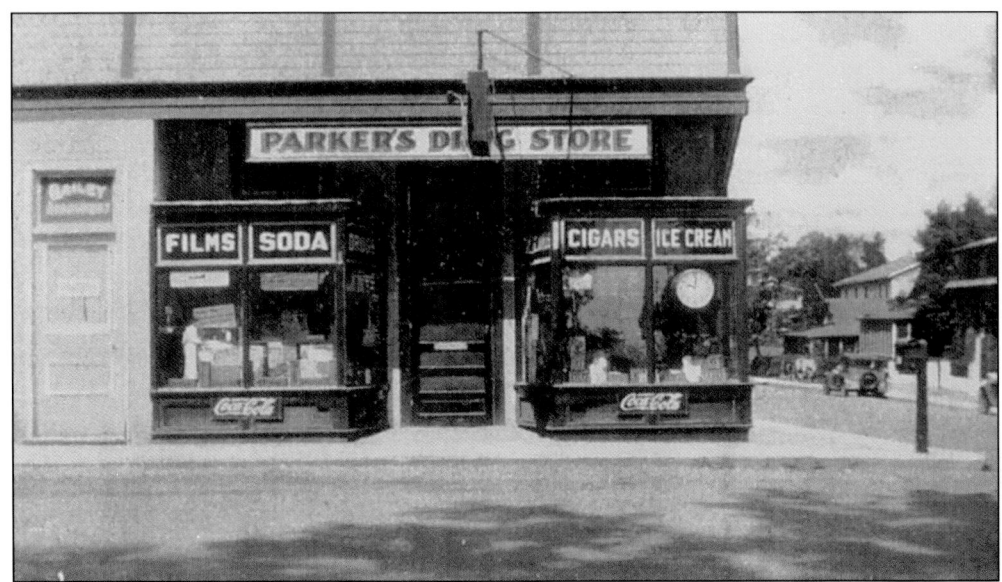

Located at the corner of Third Street and Chesapeake Avenue was Parker's Drug Store. This was the first pharmacy in Calvert County. This building, along with Lump's Department Store, Mac's Grill, and Robert S. Mead Hardware and Lumber Store, were completely destroyed by fire on December 11, 1945, causing damage estimated at $500,000.

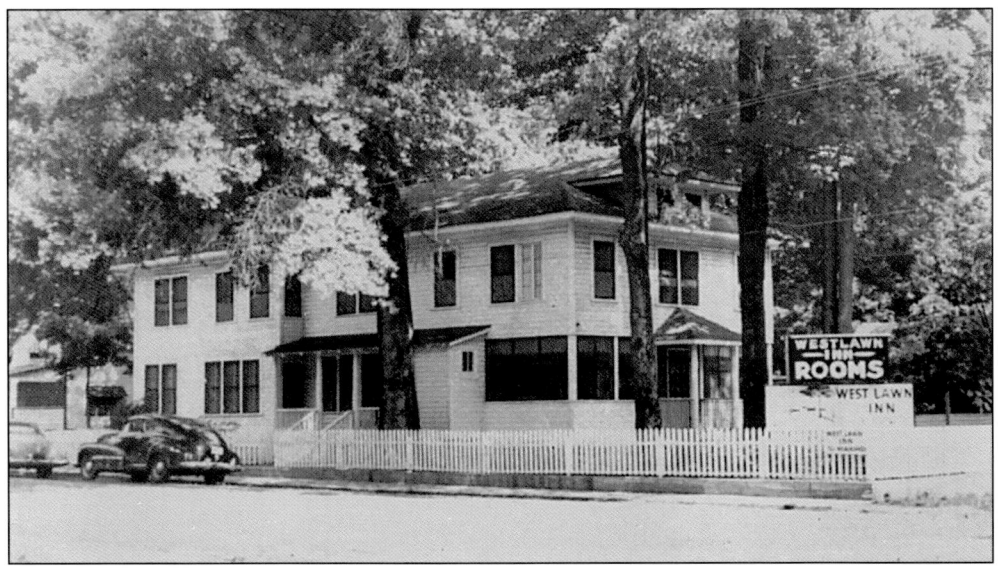

The Westlawn Inn was another large hotel located in North Beach; its proprietor was Elsie B. Chambers. The caption on the back of this postcard states the following: "Large spacious shaded guest house, all outside rooms, homelike surroundings, only one block from Chesapeake Bay." Although altered, this building is still standing at Seventh Street and Chesapeake Avenue.

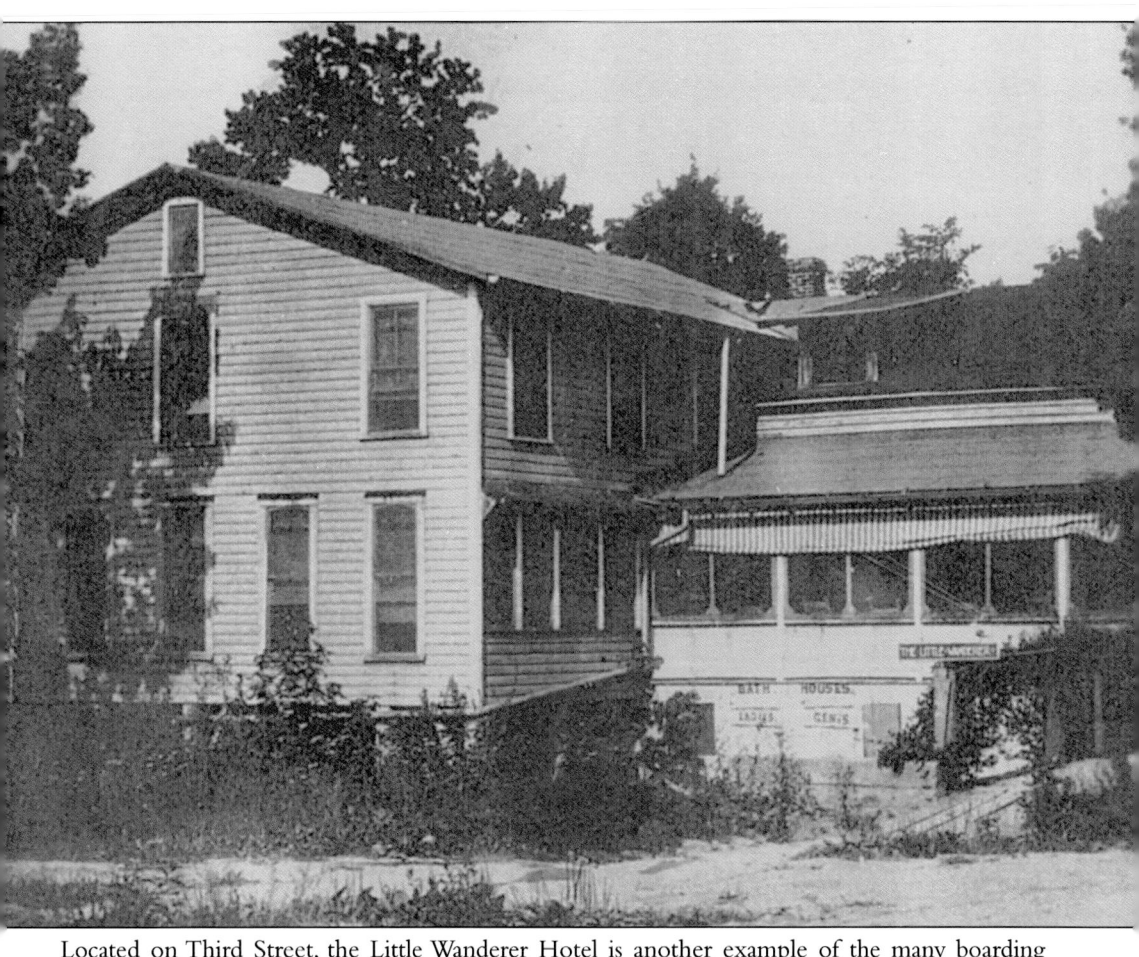

Located on Third Street, the Little Wanderer Hotel is another example of the many boarding houses and hotels that were located throughout the town. (Published by H.M. Dowling.)

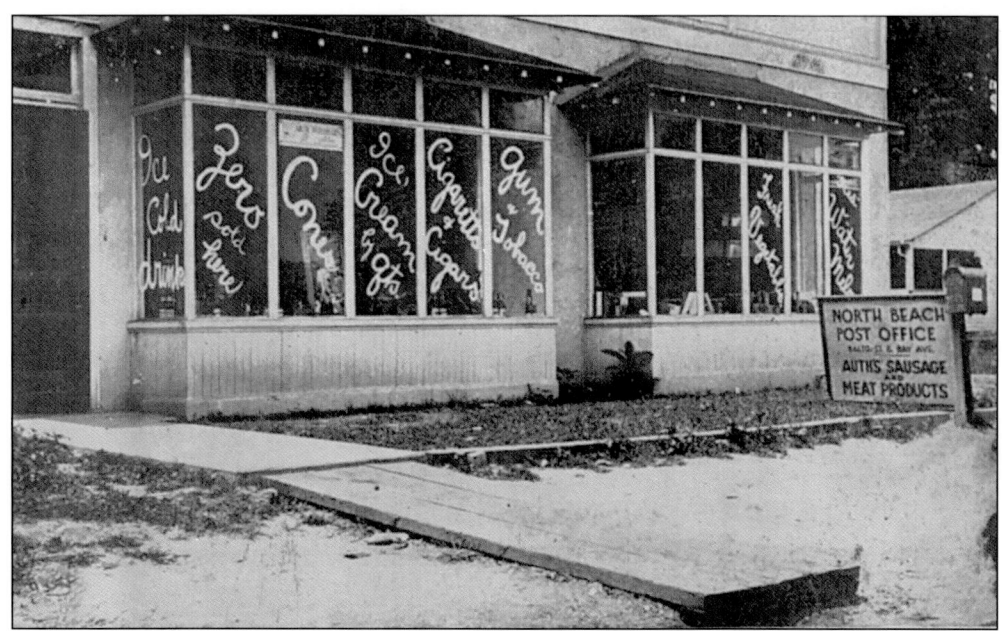

This is a view of the North Beach Post Office that was located at Baltimore Street and Bay Avenue along with a convenience store; notice the visible display windows. The original post office was opened on September 3, 1909.

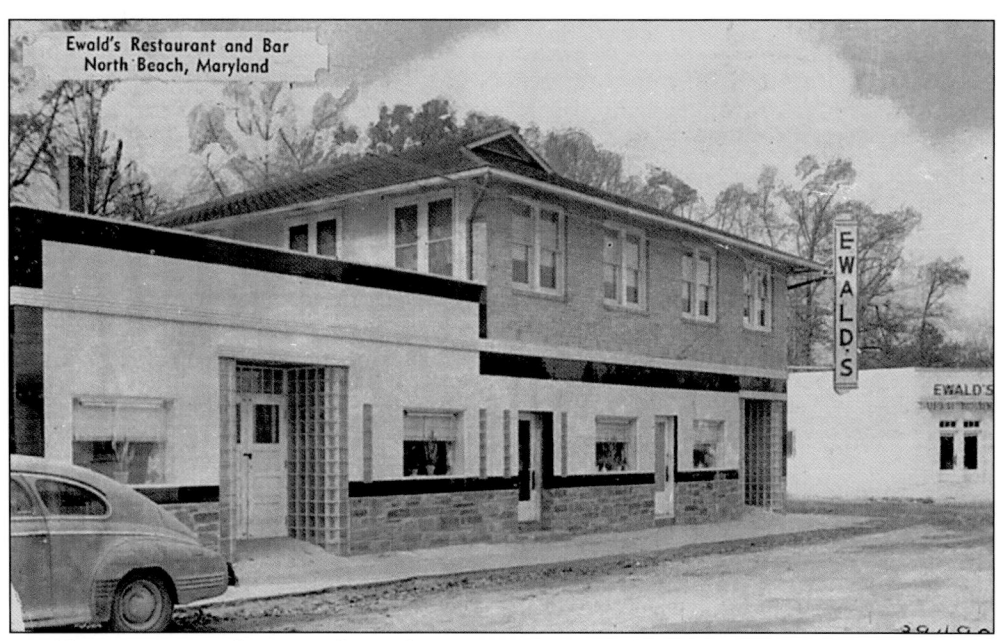

Ewalds Restaurant and Bar was located at Seventh Street and Bay Avenue. An advertisement on the back of this postcard says, "Meals cooked to order. Mixed drinks and beer. A friendly place to dine and drink." (Published by C.H. Ruth.)

Two
CHESAPEAKE BEACH

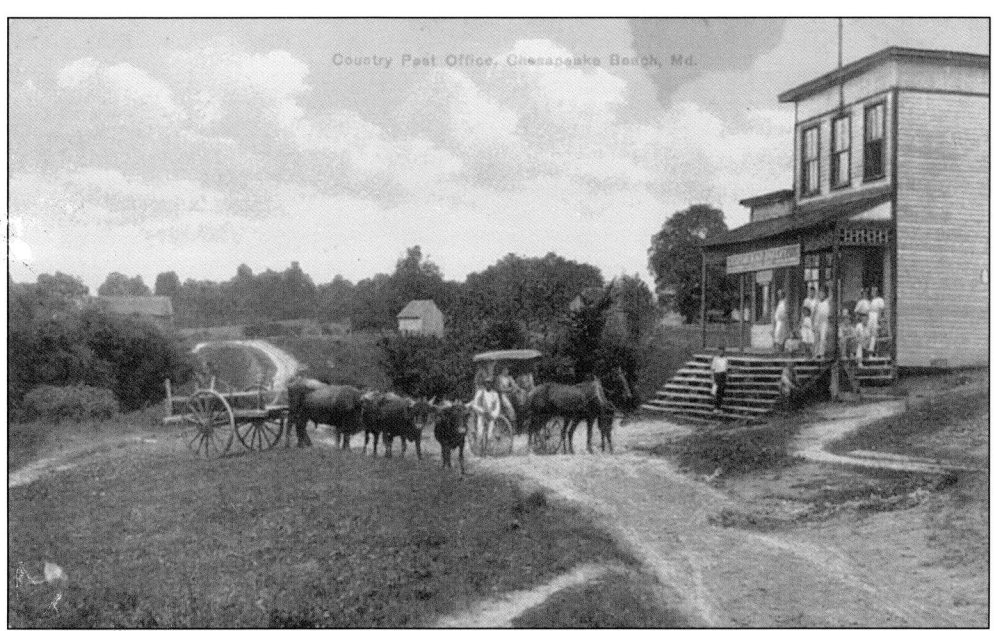

The Town of Chesapeake Beach was chartered by the Maryland General Assembly in 1894. A post office was established on June 12, 1894, but was discontinued only nine days later. The Chesapeake Beach Post Office was reopened on March 21, 1899, the same year the railroad reached this newly formed town. In addition to the post office, this building also served as a bakery.

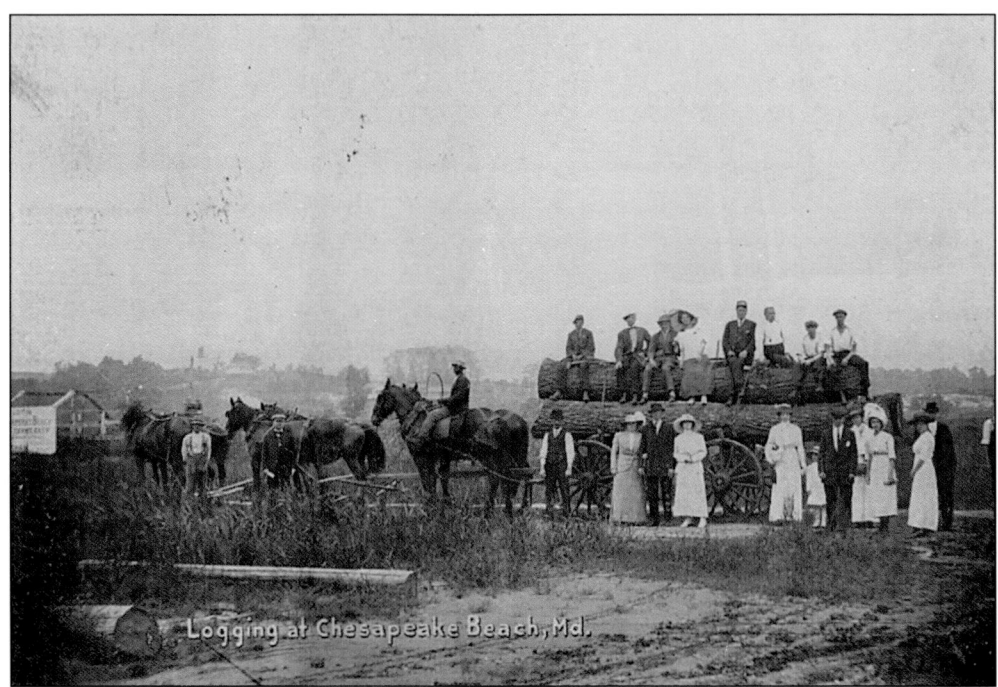

A town that was virtually uninhabited before the arrival of the Chesapeake Railway required much land clearing. The enormous size of the virgin timber can be seen in this very early postcard view.

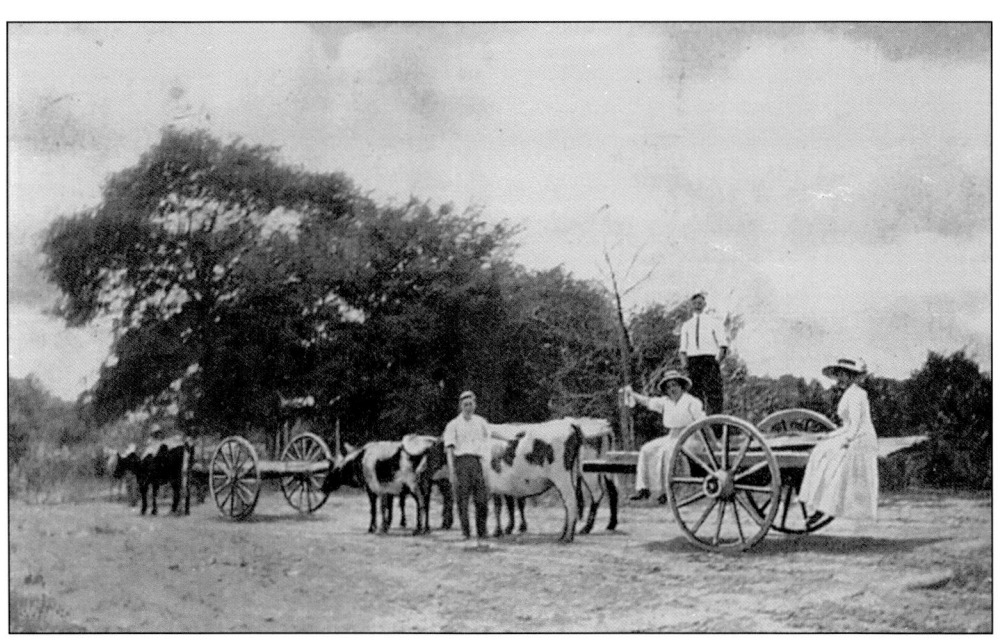

A major means of transportation in the county in the early 1900s was the ox. The sender of this postcard, mailed on August 8, 1916, wrote on the back, "They grow nothing but corn and tobacco, have not seen a hayfield since I have been here."

This postcard, mailed on June 28, 1909, has a message from the writer on the back: "Come take a ride with us in our automobile." This may have been the means of getting visitors' baggage from the Chesapeake Beach Railway Station to the local hotels.

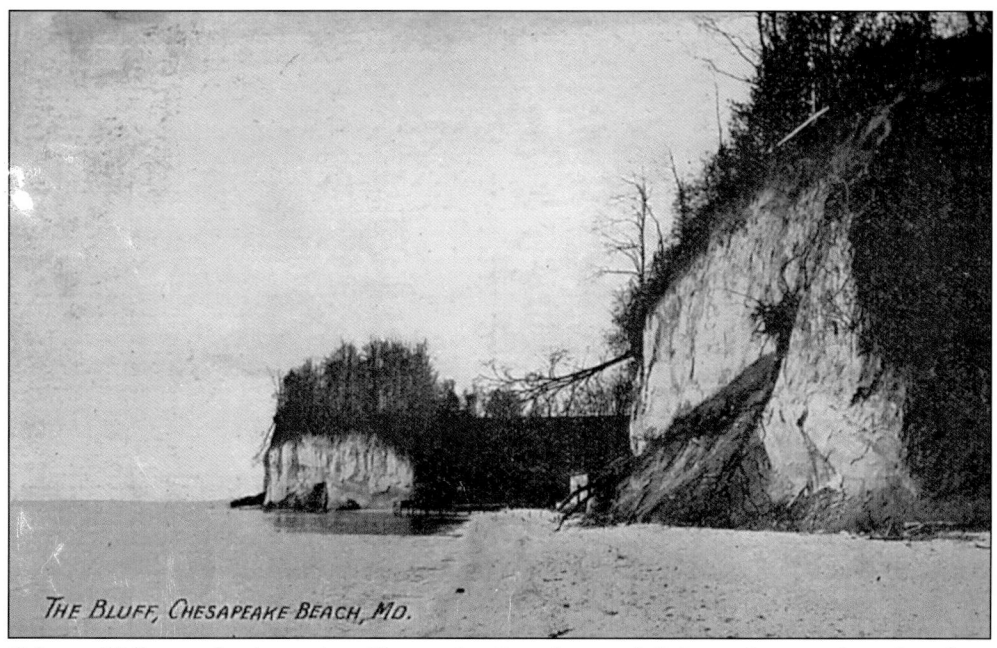

Calvert Cliffs stretch along the Chesapeake Bay shore of Calvert County. Spanning from Chesapeake Beach to Drum Point, the cliffs rise to a height of 100 feet or more in some places. (Published by I&M Ottenheimer, Baltimore, Maryland.)

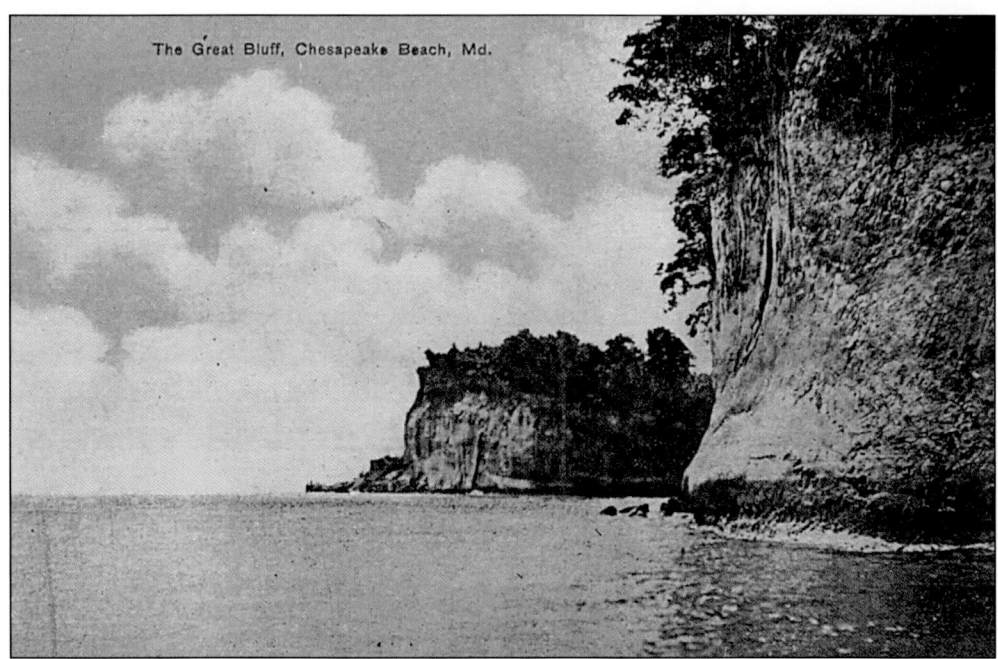

The tall cliffs provide a breathtaking view as one travels the bay by boat or takes a stroll along the white sandy beaches below the fossil-filled wall.

The cliffs have attracted fossil collectors and scientists for many years, and a favorite find is the shark teeth that can be found on the beaches. A few of the most popular spots along the cliffs are Chesapeake Beach, Plum Point, Parkers Creek, and Governors Run, to name a few. The long building on top of the bluff is the High View Hotel, and the building sitting below it is the Water Edge Hotel.

This view, looking south, is what one would see upon entering the boardwalk from the railway station.

Looking north along the boardwalk, this postcard view shows one of the covered overlooks on the east side. One of the many places to eat is seen on the west side. This is the location of the middle entrance onto the boardwalk.

This is a very early view, postmarked August 4, 1903, showing nearly the entire length of the boardwalk. This picture was most likely taken from the original steamboat pier.

This image, a view from the Chesapeake Bay looking southwest, is nearly the same as the picture above, except that the bathhouse has been expanded.

An interesting sight for both children and tourists from the city had to be the oxen walking on the boardwalk. Oxen were used extensively on farms in the county before the advent of the tractor.

The framework for a roller coaster can be seen in the background of this view, looking south. Also visible is the underside of an entrance to the boardwalk from the shoreline.

Many different types of amusement games lined the boardwalk, and the rifle range was undoubtedly one of the favorites.

Spectators watch the bathers below in this postcard dated June 26, 1909. The salt water must have been a main attraction as the sign reads, "Bathe early and avoid the rush."

Taken from nearly the same spot as the picture above, this view shows the bathhouse before the addition was built on the front. The building in the background at center is the music shell.

41

Looking south, this glimpse of the boardwalk shows a sheltered overlook on the left. On the right side is the entrance to the Great Derby. (Published by W.B. Garrison, Washington, D.C.)

This view looking south shows a merry-go-round in the distance. One can only imagine how many splinters were suffered by boardwalk patrons due to the uneven and rough boards from which the railings and walk were made.

In this view, which looks toward the bathhouses from the approximate location of the railway station, Bentley's Ice Cream Garden and Lunch Parlor is the large building on the left. It is doubtful that the man standing beside the tree in the foreground had the benefit of very much shade.

The sheltered overlook in the center of this image was lined with benches so that spectators might sit down, relax, and watch the bathers below.

The opening day of the Chesapeake Beach Resort took place on Saturday, June 9, 1900. The steamer, *J.S. Warden*, brought in visitors from Baltimore, and the Chesapeake Beach Railway brought in excursionists from the Washington area. Despite the description on this postcard, this view looks south. Notice the electric poles and lighting.

The boardwalk was on pilings over the Chesapeake Bay and ran parallel to the Calvert County shoreline, about 300 feet from the shore. Its length of approximately 1,700 feet was covered with many concession stands and a variety of amusements.

HALEYS BAND IN THE MUSIC SHELL AT CHESAPEAKE BEACH, MD., ON THE BOARD WALK.

The music shell was located at the southern end of the boardwalk and extended out over the water. Various types of entertainment were available here, one of which was Haley's Uniformed Band, pictured in this postcard.

The music shell was used for many functions; a car raffle has the locale occupied in this picture. The sign reads as follows: "This complete Brush-Nichols runabout donated to the Independent Order Sons of Jonadab of Washington D.C. will be raffled off on Labor Day September 6, 1909."

Shown here is the dancing pavilion that was located directly across from the music shell. It was also an ideal spot to get some shade at times when the music was not playing.

Mailed on August 9, 1909, this postcard depicts the dancing pavilion during more idle times. Note the many benches that were available for the non-dancing spectators watching the events inside the music shell.

This view, looking north on the boardwalk, shows the newer version of the dancing hall, built in 1925 after the old round dance hall collapsed. The sign advertises "Orange and Chocolate Ice, 10 Cents. Ice Cream Pie and Cones." (Published by Louis Kaufman, Baltimore, Maryland.)

Quieter times at the new dancing hall are the subject of this image. The track of the Great Derby can be seen over the roofline on the right. (Published by W.B. Garrison, Washington, D.C.)

One of the most prosperous kinds of business on the boardwalk had to be the souvenir stand. Two ladies look at the racks of postcards, and the sign nearby advertises Lowney's Bon-Bons made by a confectioner from Washington, D.C.

The long steamer pier that was located adjacent to the current Seventeenth Street is seen in this view, looking south. The sheltered area in the middle of the pier was a shop where canoes and rowboats could be rented.

Located at the most northern part of the boardwalk was the Oyster and Crab House, where all the equipment necessary for a fishing or crabbing outing could also be rented.

Standing in front of the Oyster and Crab House, seen on the left, this group of fisherman apparently had a successful morning. This may have been a very common scene on this part of the boardwalk.

49

On the boardwalk and to the left side of the approach from the casino is the Scenic Railway, a roller coaster. This close-up view shows the landing where the thrill ride began.

Here is another view of the Scenic Railway, this one taken from the boardwalk. "Pure Artesian Well Water," at left center, could be obtained from one of the numerous wells located along the boardwalk and on the grounds.

The track of the Scenic Railway was much lower than that of the Great Derby and extended from the boardwalk several hundred feet inland. The cost of a ride on the roller coaster was 10¢ for twice around, except on special days when the cost was lowered to 5¢.

THE GREAT DERBY, CHESAPEAKE BEACH, MD.

HIGH DIVE FROM GREAT DERBY, CHESAPEAKE BEACH, MD.

The Great Derby eventually replaced the Scenic Railway. This unusual double-view postcard, mailed on August 29, 1917, shows, in its bottom view, spectators lined up on the pier to watch a high dive.

THE GREAT DERBY, CHESAPEAKE BEACH, MD.

This is the view one would see when disembarking from the steamer to start the long walk toward the boardwalk. Apparent in this view is the magnificent size of the large attraction and the amount of area it occupies.

52

Originally named the *Republic*, this vessel was built in 1878. In 1904, it was renamed the *Dreamland* and was considered to be one of the nation's most beautiful steamboats.

The steamer *Dreamland* is shown here at the pier. *Dreamland* was the largest steamer out of Baltimore and was capable of carrying 4,000 passengers.

Dreamland, which was a 284-foot-long side-wheeler, made the 50-mile trip from Baltimore to the western shore daily in the summer season during the years from 1910 to 1925.

The Maryland House, at lower center, was situated just below the Belvedere Hotel, which sat on the bluff to the right. The proprietor of the Maryland House was Mrs. M.R. Clark.

This early scene shows the distance of the boardwalk from the shore. To the left is the dancing pavilion, and near the center is the Scenic Railway. This view was probably taken from near the location of the current Rod and Reel Restaurant.

One of the earliest postcard images of Chesapeake Beach, this birds-eye view shows the railway station against the tree line and the steamboat pier across from the station.

With the merry-go-round to the right, this early scene shows the area still under construction. Piles of cut trees that were used for pilings to support the boardwalk are also visible.

Mailed on July 1, 1915, this postcard shows a steamboat at the end of the new pier. The merry-go-round is the southernmost building.

Taken from a knoll south of the current Seventeenth Street, this view looks north up the boardwalk. The large circular shape of the merry-go-round building can be seen at the end.

57

A main attraction of the resort, enjoyed by children and adults alike, had to be the merry-go-round, which was built by one of the finest carousel makers in America. Its music was supplied by a Whurlitzer Band Organ. The carousel was purchased by Prince George's County in 1974, was restored, and is now located in Watkins Regional Park. (Published by I&M Ottenheimer, Baltimore, Maryland.)

This wading pier originated from underneath the bathhouse on the boardwalk. The stakes visible in the background are part of a net that was used to keep out the sea nettles.

One of the major attractions to visitors at the Chesapeake Resort was the salt-water bathing. It was advertised as "equal to any bathing found on the Atlantic Coast." (Published by Frederick A. Schultz.)

The bay remained shallow for quite a distance from the beach and had no undertow or strong currents, making the area perfectly safe for the amusement of both adults and children. The water was described as clean, pure, and briny.

The first photo gallery at the Chesapeake Resort was that of A. Freedley, and it was located directly on the boardwalk. Many of Freedley's photos were made into postcards, such as this example. The very familiar bench made out of tree limbs is shown here, and the bathers are pictured wearing the rented suits that were available. Notice the monogram in the center of the suits.

Located between the north pier and the second entrance onto the boardwalk was this wide sandy beach known as the babies' bathing place. The large white building is Bentley's Ice Cream Garden and Lunch Parlor.

Another view of the sandy beach looks north toward Bentley's. The picture was taken from the second entrance onto the boardwalk, which would today be located opposite the Chesapeake Station Development.

In addition to being the steamboat pier, this long pier was also used for crabbing and fishing. Fishing and crabbing tackle could be rented from the establishment at the end of the pier.

One popular activity at the beach was to have a picnic underneath the large shade trees and enjoy the refreshing bay breeze.

A shady spot along the sandy beach is pictured here. The resort boasted of having beautiful flowers of all kinds and colors, lawns of velvet green, and nooks and settees for couples who do not like the crowds.

Located south of present-day Seventeenth Street, this campground was a popular spot with vacationers, who would sometimes arrive in the spring and stay all summer long.

Capturing another campground scene, this unusual double-view card shows a tent in the inserted picture. This group appears to be a boys club of some kind.

This view of the resort grounds, located some distance from the shore, shows a settee where couples could sit and get away from it all, as well as a well-manicured lawn.

Stebbins Avenue, named for W.H. Stebbins, the proprietor of the nearby Parks Café, was located between the railway station and Bentley's Ice Cream Garden and Lunch Parlor on the left.

In another view of Stebbins Avenue with Bentley's in the background, the roof corner in the right foreground is that of the railway station.

Located approximately 100 feet south of the railway station, Parks Café was described as "One of the oldest and best lunchrooms at the beach." It claimed to have first-class meals, good service, and city prices. The sign on the porch column says "Tea, Coffee, Milk, Pie, Lemonade 5¢."

Capt. Freedley's was another favorite lunching spot. Outside tables were available to patrons who wanted to enjoy the fresh salt air while eating, or to those who just wanted to take a refreshing break from the boardwalk amusements.

This is a view of the casino from the bay side. Otto Mears, a railroad builder from Colorado, had a vision to build a Monte Carlo at Chesapeake Beach that included a racetrack along with a casino.

Once the casino and racetrack were built and ready to open, it was discovered that Calvert County authorities would not issue the Chesapeake Beach Improvement Company a gambling license.

Even though the building was not used for gambling, as was originally intended, the name "Casino" was never changed. It was opened as an eating establishment. In 1948, when slot machines were legalized in Calvert County, this became one of the many buildings in the county where they could be played. (Published by I&M Ottenheimer, Baltimore, Maryland.)

This close-up view shows the bathhouse with the addition on the front and, on the side, the office of T.A. Wickersham, General Agent, Land Department.

The dream of the founders of the Washington and Chesapeake Beach Railway was to build a luxurious gambling and beach resort. Such a resort was to include two grandiose hotels named the Chesapeake and the Patuxent.

Due to financial problems, the grandiose hotels that were originally planned for the resort never materialized. The principal hotel of the Chesapeake Beach Resort became the Belvedere Hotel, also known as Otto Mears' Clubhouse. This early card was mailed on August 21, 1908.

This view of the Belvedere Hotel was taken from the boardwalk. The pier on the left is the entrance, which would be near the present-day Seventeenth Street, leading to the steamboat landing.

On March 30, 1923, the elegant Belvedere Hotel caught on fire and was completely destroyed. The conflagration started about two blocks away and threatened the entire resort. With the North Beach Volunteer Fire Department being the only fire department in the county at the time, help was summoned from the Washington, D.C. Fire Department. The Chesapeake Beach Resort lost its most valuable building.

Water Edge Hotel, Chesapeake Beach, Md.

Mailed on August 21, 1909, this postcard shows the Water Edge Hotel, which was owned by G. Marinelli. The hotel was located at the site of the present-day Brownies Beach, near the shore.

Located on a tall bluff a little to the north and slightly behind the Water Edge Hotel stood the High View Hotel. This building was unfortunately destroyed by fire. This postcard was sent on July 28, 1911.

People in this picture are waiting for the train to arrive. A variety of carts will haul the various types of freight to farms and businesses nearby.

For over 300 years, tobacco was the main source of income for farmers in Calvert County. The large barrel-shaped containers on the carts are called hogsheads and hold an average of 600 pounds of packed tobacco. These will be loaded onto freight cars and carried to the market to be sold. It was a common practice for the Chesapeake Railway to use freight cars from the Baltimore and Ohio Railway.

Originally chartered in 1891 as the Washington and Chesapeake Beach Railway Company, the company lasted only a short time due to financial difficulties. In 1896, reorganization took place, and the Chesapeake Beach Railway Company was formed. The railroad was completed in 1899, but the resort was not ready to open until a year later. (Published by I&M Ottenheimer, Baltimore, Maryland.)

Here, passengers are disembarking and heading toward the railway station or the boardwalk. During the summer season, the trains made five trips a day during the week and six trips a day on Sundays and holidays.

Looking east toward the railway station, this is a rare view of the train tracks. The line extended 28 miles from the northeast corner of the District of Columbia border to the mouth of Fishing Creek in Calvert County.

Departing from the Tuscan red- and gold-painted passenger cars, these visitors will be spending the day at the many concession stands, amusements, and establishments available to them on the boardwalk. The last train to leave for the day departed the station at 10 p.m.

This view of the railway station is quite deceiving as the negative was reversed when this postcard was made. The long open end of the station is actually on the left end of the building, towards the bay. (Published by I&M Ottenheimer, Baltimore, Maryland.)

The Chesapeake Railway Station is the only remaining station of the two that once existed in Calvert County. It is listed on the National Register of Historic Places.

The last train departed Chesapeake Beach on April 15, 1935, and the depot was officially closed at that time. Today, the depot is the site of the Chesapeake Beach Railway Museum.

Due to a steady decline in business, the management of the Chesapeake Resort began to look for ways to rejuvenate the park in the latter part of the 1920s. The main hotel had been lost to fire in 1923, and the aging boardwalk and buildings were deteriorating.

The old boardwalk, with its concessions and amusements, was torn down, and all the amusements were built inland. Concessions and rides were placed on a tall bluff where the picnic grounds were located.

The newly formed management and renovated park would be named Seaside Park, and opening day was planned for May 30, 1930. For a while, it appeared that business would be booming once again. (Published by the Process Photo Studio, Chicago, Illinois.)

78

Due to the shallow depth of the bay at this point, the steamboat pier was required to be nearly a mile long to accommodate the large steamers. (Published by Orcajo Photo Art.)

This view of the steamboat pier shows that it was built in a southerly direction and curved out into the bay. (Published by Orcajo Photo Art.)

Due to the extreme length of the steamboat pier, excursionists were exhausted by the time they walked to the park. A miniature train service was soon added to carry passengers back and forth. (Published by Orcajo Photo Art.)

The original miniature locomotive was run by a steam engine, but in later years, an automobile engine replaced it. The streamlined version of the miniature train can be seen in this view.

Owned by the Wilson Line, the *State of Delaware* was launched on April 3, 1923. It began running to Seaside Park from Pier 8, Light Street, Baltimore, on May 28, 1931. (Published by the Process Photo Studio.)

This steamer was originally built in 1885 and called the *Brandywine*. Rebuilt in 1936 as the *Dixie*, the contemporary-looking steamer was ahead of its time in design.

Also owned by the Wilson Line, the *Dixie* rests at the head of the pier along with the miniature train heading toward the park. When *Dixie's* service ended at Seaside Park, it was relocated to Boston Harbor, where the Southern name of *Dixie* was changed to *Pilgrim Belle*. (Published by Orcajo Photo Art, Dayton, Ohio.)

The steamer at the head of the pier in this view is the *Bay Belle*. Originally built in 1910 as the *City of Wilmington*, it was rebuilt in 1941 and called the *Bay Belle*. Regular service to Seaside Park by the *Bay Belle* began on June 8, 1941. This service ended in 1942 when the steamer began being used for wartime service. Steamboat service also ended for the park.

The Casino continued to be a restaurant and a place to play bingo until slot machines were legalized in Calvert County in 1948. Once the "one-armed bandits" could be played, this building became a very popular gambling spot. (Published by the Process Photo Studio, Chicago, Illinois.)

This is a view of the Ballroom with its entrance facing the north. "Bathing Beauty Contests" were held here (as the sign is advertising), and bands played for dancing. The Tiny Meeker Orchestra was a regular act at the Ballroom. This building was totally destroyed by fire on July 1[1] 1977.

8875-C. Bathing Pool. Seaside Park, Md.

The southern side of the ballroom is seen here, along with the very popular salt-water pool. For the swimmers not brave enough to share the bay with the sea nettles, this was the perfect alternative.

5663-B. View of Bay. Seaside Park, Md.

Seaside Park existed until 1946, when a newly organized company, Chesapeake Beach Park, Inc., took over. The park operated as Chesapeake Beach Park until it closed in 1972 and the gates were closed for good.

Opened in 1936, Wesley Stinnett's Restaurant and Bar is a landmark in Chesapeake Beach and continues to be in business today. This scene shows the establishment's crowded parking lot.

Owned by Gordon Stinnett, this High Roller-style boat was built in Florida. The caption on the back of the postcard reads, "Fishing party boats leaving daily from the Rod and Reel."

"Let's go fishing" North Beach, Md.

This c. 1947 view of the harbor is actually in Chesapeake Beach and not North Beach, as the card states. Buddy Kellam owned the large boat, named the *Navajo*, in the foreground. (Published by R.D. Grund, North Beach, Maryland.)

Let's Go Fishin' Jones Fishing Fleet North Beach, Md.

A fine fleet of charter fishing boats from the 1940s is the subject of another view captured in Chesapeake Beach, not North Beach. (Published by R.D. Grund, North Beach, Maryland.)

Three

PRINCE FREDERICK

The Calvert County seat was named Prince Frederick in honor of the eldest son of King George I of England, then Prince of Wales. The more centralized location for the county seat was better suited for the people of Calvert County than the previous location at Calvertown. The view in this early postcard, postmarked December 27, 1910, looks north into town.

STREET SCENE, PRINCE FREDERICK, MD.

A wide dirt road goes through the center of town in this desolate scene. Present-day Main Street follows the same route that existed many years ago. This postcard was mailed on October 17, 1910.

Showing a trolley car in Prince Frederick, this rare card has a postmark of April 30, 1907, and was sent from Prince Fredericktown, Maryland. The word "Town" was dropped from the name around 1910.

This postcard, mailed April 25, 1911, shows the fifth courthouse built in Calvert County. This courthouse was rebuilt after the great fire of 1882. It was during this fire that nearly all of the records dating back to the establishment of the county were destroyed. A few months later, another fire took place where the rescued records had been stored and completely destroyed them all.

The sixth courthouse of Calvert County was erected in 1915 and serves to the present day. A memorial to the veterans of World War I is located near the main entrance.

Dated December 23, 1914, this postcard presents the Prince Frederick Bank of the Eastern Shore Trust Co. Later the name was changed to the County Trust Company, then to the Maryland National Bank. Rufus B. Smoot was one of the longtime cashiers at the original bank.

Shown here is the very popular Calvert Hotel that was owned and operated by George D. Turner. Along the entire front porch is wisteria vine, a portion of which still exists today. Unfortunately, on July 11, 1967, the Calvert Hotel was totally destroyed by fire.

Prince Frederick Department Store, also known as Goldstein's, was reopened in July of 1942 after a fire destroyed the earlier store. This building was purchased by the Calvert County government in June 1979 for use as office space. (Published by Embetone.)

The center of activity in Prince Frederick for many years was the Evans Hotel, which was originally owned and operated by two brothers, Frank and Reynold Evans. In later years, Johnny Sotec operated the business, and from 1958 to 1981, George Sachs ran it. It has since been torn down and is now a parking lot owned by the Calvert County government. (Published by C.H. Ruth, Washington, D.C.)

Located in the southern portion of Prince Frederick, Rustic Farm was a restaurant surrounded by pine trees that specialized in the finest steaks, seafood, pizza, and Maryland fried chicken. The building still stands and still houses a restaurant. (Published by C.H. Ruth, Washington, D.C.)

Calvert County High School was located at the northern end of Prince Frederick and currently serves as a school for the middle grades. This school was erected in 1947 and remained the high school until the opening of a newer school, which was dedicated on May 5, 1963. (Published by C.H. Ruth, Washington, D.C.)

This view of the Calvert County Hospital shows the building after additions were completed on both ends. Situated on land donated by John B. Gray, the hospital opened in 1919. In 1968, it became the first licensed nursing home in Calvert County and was known as the Calvert House.

This is a picture of the new and more modern hospital that opened in 1953, replacing the older hospital that had been built in 1919. This building has since been replaced by the existing Calvert Memorial Hospital, which was dedicated in 1978. (Published by Embetone, Frederick, Maryland.)

The Wesley Methodist Church was located on a knoll on what is now Armory Road. Dedicated in 1891, the church remained in existence until 1955, when it joined with Asbury Methodist Church and Central Methodist Church to become what is known today as Trinity Church. (Published by C.H. Ruth, Washington, D.C.)

St. Paul's Episcopal Church, erected in 1842, is located on the south side of Church Street. The first service in the new church was held on Christmas Day in 1842. (Published by Henry H. Ahrens, Charlotte, North Carolina.)

Saint John Vianney Church was the third Catholic church in the county. Canonically established as an independent parish on May 29, 1965, the church was served by the Reverend Joseph J. Naughton as the first pastor. (Published by C.H. Ruth, Washington, D.C.)

The A&P Store was the first business in the original Prince Frederick Shopping Center; the store was officially opened on February 14, 1961. Within a few months, a five-and-ten-cent store, Roland Dry Cleaners, P&L Liquor Store, and Charlie Brocato's Barbershop would be added.

Four

SOLOMONS ISLAND

Previously known as Sandy Island, this area underwent a name change to Solomons Island when a businessman by the name of Isaac Solomon purchased the island to open an oyster-canning factory. Though the factory was in existence for a very short time (1868–1875), the name has remained.

Solomons Island is located at the southern end of Calvert County. For many years, the only connection between the island and the mainland was a wooden bridge spanning about 550 feet. This very early card, with a postmark of October 30, 1906, was mailed by longtime Solomons resident, Adolph P. Kopp. The building seen here is the Solomons United Methodist Church.

Entering Solomons from Mainland

This is another early view of the bridge at the point where one would enter onto the island. Notice in this view that a concrete sea wall has been added to help stop the bridge from eroding away.

This view, looking south at the island, shows how the length of the original bridge span is being shortened due to the discarding of oyster shells. To the left of the bridge is the part of the harbor called "the Narrows;" to the right is the Patuxent River.

To the north of the island is a section called Avondale, or as it is known to some locals, Johnstown. In this view, looking northeast, the old wooden bridge is visible. This early card is postmarked July 10, 1909.

This view shows the northern section of Avondale. The home on the far right was built in 1910 for Ida K. and Joseph E. Johnson Sr.

Dated July 21, 1908, this postcard features a view that looks north toward the island from the Patuxent River. The house on the far right is the oldest house in Solomons and is still standing today.

This view, also looking north toward the island from the river, shows four duplex dwellings that are believed to have been built by Isaac Solomons for his canning factory workers.

Originally, Patuxent Avenue spanned nearly the entire length of the island on the river side. The first building in this scene is St. Peter's Episcopal Church, the next house is that of Perry Evans, and next is the residence of Dr. Earl Coster.

Dated June 19, 1918, this postcard shows the dirt road, known as Patuxent Avenue, and the telephone poles on the shore side of the road before they were moved further inland.

Looking southeast toward the island, this view features Patuxent Avenue before the road was widened and the concrete sea wall was added. The building on the far left is the public school.

Mailed on August 16, 1922, this postcard shows the widened road and the concrete sea wall that was built to help stop erosion caused by the river. The pitch in between the sections of concrete would be picked out by children and chewed like gum.

The sender of this postcard, dated December 12, 1906, described this scene as Post Office Avenue. Notice the horse and buggy and the tall picket fence.

The old J.F. Webster and Brother Store was located on low-lying ground, making this area and the store very susceptible to flooding. This postcard was mailed on November 12, 1906.

In the early days, a large portion of Solomons consisted of farmland, as can be seen in this unusual view. The object with the stacks in the background is the Dewey Dry Dock.

Here is another card sent by longtime Solomons resident Adolph Kopp that describes "The Main Street on which I live." Today the Chesapeake Biological Laboratory is located on this waterfront street.

105

In this view, looking southeast toward Solomons from the Patuxent River, the fields and barns of Strathmore Farm are on the left. The Strathmore Dairy, in existence from 1938 to 1942, was located on this farm. (Published by Auburn Greeting Card Co., Auburn, Indiana.)

Located on the southwest end of the island is a tract of land called Sandy Point. Vacationers once set up camp here, and in later years, the spot was the location of a ball field.

The harbor was surrounded by many businesses, and its natural layout made it a very popular shelter for boaters against the weather.

The square scow in the foreground was used to haul fish pound nets. It would be piled high with nets and towed behind a boat out into the river or bay, where the nets would then be placed. On the right is the shed of Merrill Carey, who ran an oyster-shucking and crab-shedding business for the locals.

A view taken from the approximate location of the current Tiki Bar shows a Chesapeake Bay schooner moored in the harbor. To the right is the mouth of Back Creek and the tip of Mols Leg Island. (Published by Auburn Post Card Manufacturing Co., Auburn, Indiana.)

This picture was taken from the back street behind the Catholic church. Clyde Dove owned the smaller boat in the foreground, and James Webster owned the skipjack.

The 42-foot boat *James Aubrey,* owned and operated by Captain Ike Hill and his son, Wilson, brought children from Olivet, Rousby, and Dowell for school. It was in operation from 1925 until 1935.

This view from the harbor shows a skipjack tied up at the dock. This was the location of the Patuxent Lodge of the Knights of Pythias, organized in 1877, and the oldest house in Solomons can be seen on the far left. The postcard was mailed on November 25, 1907.

The plentiful supply of oysters in the Patuxent River and the Chesapeake Bay attracted Isaac Solomons to this small island for the establishment of his cannery. The type of vessel shown here is known as a brogan, which is slightly smaller than the famous bugeye.

During the height of the oyster boom, the harbor at Solomons was continuously filled with oyster boats. Skipjacks, bugeyes, brogans, and the pungy were all familiar sights in the harbor.

Kate please come down, I'll get the charm B. to meet pu at the

In 1905, the floating dry-dock *Dewey* was brought to the Patuxent River for testing after being built in Sparrows Point, Maryland, for use by the U.S. Navy in the Philippines. Tests were conducted off Solomons Island, as this was the only harbor deep enough and large enough to accommodate the large battleships.

Mount Vernon and *Monticello* were German merchant vessels captured by the United States in 1917 during World War I. The ships were moored at this location, chosen for the depth of the river and the excellent protection from the elements, from 1937 until 1940. Known as the "Ghost Fleet," the *Mount Vernon* and *Monticello* were later joined by four other vessels.

This c. 1936 picture was taken in front of the Rekar's Hotel and shows the Shell brand gas pumps. The boat to the right, owned by Captain Vaughn Thomas, was named *Fun* and was built in 1935. The boat docked on the left is *Manie Venable*.

Located behind Bowen's Inn was the dock for Bowen's Fishing Fleet, boasted as "One of the largest and best equipped on the bay." Some of the boats in this fleet were named the *Althea*, *Kay*, *Red Sails*, *Shirley Temple*, and *Miss Maryland*.

The fishing fleet of Captain Leon Langley is pictured here. The 48-foot *Miss Solomons* is the boat on the far right, and it was used as a ferry, carrying workers between Solomons and the Patuxent River Naval Air Station. Captained by Joseph E. Johnson Jr., *Miss Solomons* was utilized from 1941 until the Governor Thomas Johnson Bridge was opened in 1977.

Another fine example of a fishing charter boat is the *Sea Cloud*, owned by Vincent Langley. Originally powered by a V-12 engine, it proved to be too powerful and had to be replaced with a smaller marine engine. (Published by Edward Wells, Dumont, New Jersey.)

St. Peter's Episcopal Church, built in 1889, is the only surviving board-and-batten church in Calvert County. Its distinguished Gothic-style features are evident in this image.

Built in 1870, the Solomons United Methodist Church was the first church to be built on Solomons Island and, for many years, was the northernmost building until the establishment of the H.M. Woodburn and J.C. Lore Oyster Houses.

Built in 1895, the St. Mary's Star of the Sea Catholic Church was the first Catholic church built in the county. Originally located on what is today Sedwick Avenue, the church was moved in the 1920s to the rear of the present-day Our Lady Star of the Sea Church. In 1936, the original church was destroyed by fire.

Father Maurice Alexander was the first resident pastor of Solomons' Catholic Church, later named, Our Lady Star of the Sea. This beautiful church, which was dedicated in 1928, is situated on a small knoll and boasts a commanding view of the Patuxent River.

Shown here is a photograph of the three-room schoolhouse that was dedicated in 1882. Miss Susan Magruder served the school as a principal and teacher for 21 years. Files Ice Cream Parlor is on the right, and the Locust Inn is on the left.

Built in 1925, this building served as Solomons Elementary School from 1925 until 1972 and as Solomons High School from 1925 until 1939. Today, this building houses the administrative offices of the Calvert County Marine Museum.

This large building, constructed in 1902 for William and Lorenzo Northam, was originally the Hotel Northampton and was located just south of the Clarence Davis residence. The name was changed to the Northam Hotel, when the structure later became the personal residence of the Northam family.

Seen in this turn-of-the-century view of Point Patience, this boarding house was run by the Marburger family. In the 1930s, it was known as the Point Patience Hotel and was run by Mollie Roberts. Fried chicken must have been the specialty, as the author's father recalls delivering three or four cases of chickens every week. The U.S. Navy purchased the property in the 1940s. This postcard was mailed on January 4, 1909.

This large Victorian mansard-roof home was built for Captain James Northam, but in 1918, it was established as the Bowen's Inn by George M. Bowen. The building was torn down in 1976.

In 1937, Bowen's Inn was enlarged and modernized with the addition of 40 rooms. One could say this place had everything: a restaurant, a beer garden, charter boats, and a place to spend a comfortable night.

118

Willis and Samantha Overton owned this original home, which, in later years, became a boarding house called Avondale. A longtime postmaster of Solomons, William Condiff, married the Overton's daughter, Marie, and the building became their home. The house is still standing today and is a private residence.

Facing the Patuxent River is this large boarding house called the Locust Inn. This home was once owned by George Condiff, also a postmaster of Solomons and the brother of William Condiff, the owner of Avondale. This house also still survives today.

The Parish House was a center of activity on the island for many years. It served as the town hall, library, high school, and even a movie theater at different times throughout its existence. To the left is the Episcopal rectory. The large basswood trees in the center, which still stand today, are known by local residents as "Pump Trees" because the town water pump was once located beneath them.

This building, known as Evan's Pavilion, was established in 1919 by Perry Evans and his son, Reynold. Reynold was also a part owner of the Evans Hotel in Prince Frederick. Throughout its existence, the building has housed an ice cream parlor, a movie theater, a dance hall, and a restaurant. Today it is known as the Solomons Pier Restaurant.

This is a view of the Rekar's Hotel with J.C. Webster's store to the left. The large 42-room hotel was begun in 1922 by William and Mary Rekar and was torn down around 1961.

On the bluff overlooking the harbor is the brick bank building of the Eastern Shore Trust Company of Maryland. In 1933, it became the County Trust Company, and in 1961, it became the Maryland National Bank. Today, the building is the location of a gift shop. The house to the far left was known as the Clarence Davis house and is today's Solomons Victorian Inn.

In 1922, the Chesapeake Biological Laboratory was founded by Dr. Reginald Truitt, who had begun his work out of a shed belonging to Merrill Carey. This Colonial-style brick building, dedicated on July 19, 1932, is the oldest state-supported marine research unit on the East Coast. (Published by the Collotype Co., Elizabeth, New Jersey and New York.)

Consisting of approximately 37 acres, nearly the entire island is visible in this bird's-eye view. Even though the commercial oyster houses and the large wooden boatbuilding companies have disappeared, the water is still Solomons' main attraction. (Published by Auburn Greeting Card Co., Auburn, Indiana.)

Five

OTHER TOWNS

The small town of Owings had one of the busiest train depots on the Chesapeake Beach Railways route. Measuring 18 feet by 61 feet, the depot was a major distribution point for the freight and mail of Calvert County. The depot closed in 1935.

Federal Oaks, Sunderland, Md.

The western end of this large home, which was built prior to 1890, served as a store and post office for the Sunderland area. In 1929, the small west-end section was torn down and replaced with a much larger store known today as Hardesty's Grocery.

LOWER MARLBORO, MD.

In an act passed in 1683 by the Maryland General Assembly for "The Laying out of Towns," Coxtown, later known as Lower Marlboro, was one of the first port towns in the county to be established.

Located on the Chesapeake Bay, south of Chesapeake Beach, is the town of Randle Cliffs. Originally established as a summer town with rental cottages, the town is now home to a U.S. Naval Research Laboratory. (Published by Auburn Post Card Manufacturing Co., Auburn, Indiana.)

The Corrin Strong Dining Hall is located at Camp Theodore Roosevelt, which was the first Boy Scout camp in the United States and is today designated as a Calvert County Historic District. The mess hall was dedicated in 1937 at the National Boy Scout Jamboree. The camp ceased to operate as a camp in 1967. (Published by Artvue Post Card Co., New York, New York.)

Plum Point is located on the shores of the Chesapeake Bay and was made a regular stop on the route of the Weems Steamboat Company as early as 1868. The home pictured here was the residence of Joseph and Hester Dixon.

This early postcard, dated September 26, 1906, features Christ Episcopal Church. It is at this location that the traditional Calvert County Jousting Tournament is held each year—jousting being the official sport of the State of Maryland.

Located south of Prince Frederick on the Chesapeake Bay is Scientist Cliffs, a community begun in 1937 by Flippo and Ann Gravatt as a private summer retreat for scientists.

Located at Governor's Run on a hilltop overlooking the bay was Cliffs Hotel, originally the residence of the William Dorsey family. This building was destroyed by fire.

Long Beach-air view new area showing jetties, harbor, wooded, rolling hills.

This large development was established as a summer beach community in the mid-1950s by Malcolm Rockhill. Known as Flag Harbor, the harbor provides year-round protective anchorage. (Published by Willens and Co., Chicago, Illinois.)

Built in 1883, the Drum Point Lighthouse is one of the few existing screwpile lighthouses and is listed on the National Register of Historic Places. Decommissioned in 1963, the lighthouse was moved in 1975 to its present location at the Calvert Marine Museum. This card is postmarked August 29, 1907.